Piloto

tus raíces son tus alas ---

¡Vuela!

PILOTO

Editorial **El BéIsMAn**

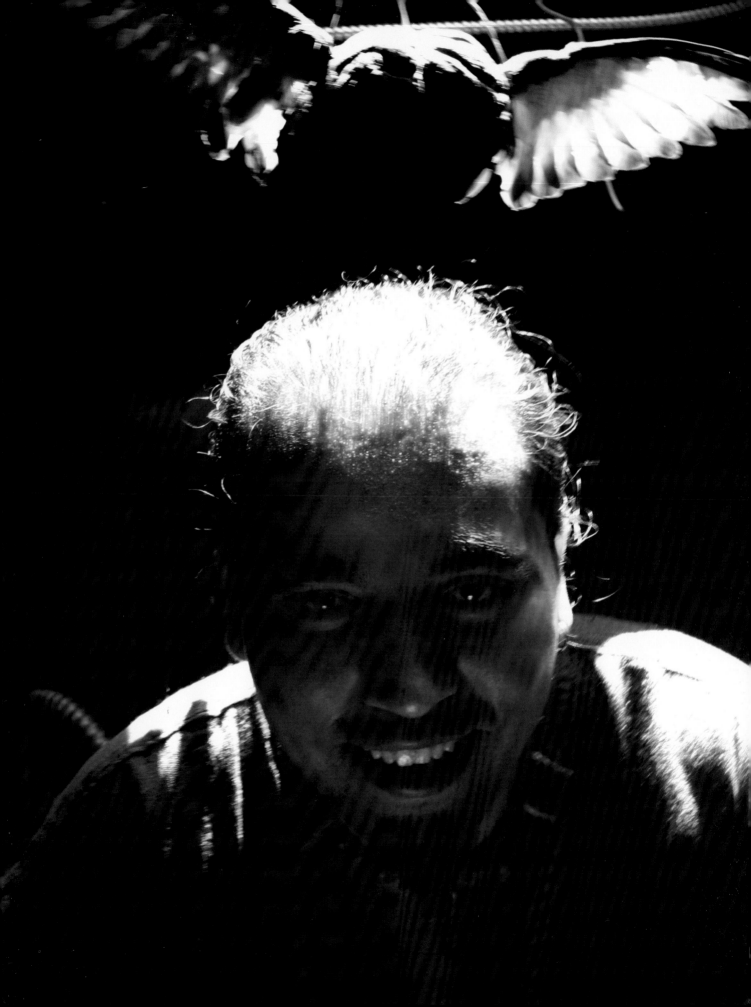

SCULPTURE

Alfonso Piloto Nieves Ruiz

EDITOR
Francisco Piña

PHOTOGRAPHERS
Tim Arroyo
Magda Marczewska

PROOFREADERS
Emily Ekstrand
Magdalena Mora
Juan Ignacio Mora
O.M. Ulloa

TRANSLATORS
Emily Ekstrand
Diana Hinojosa
Jorge Montiel

CONSIGLIERES
Raúl Dorantes
Juan Mora-Torres

COVER
El CEO de otros tiempos, 2013. High-fire clay, oxides, high-fire glaze, concrete, rebars, auto part, roots, wire, plastic garbage, mirrors, acrylic. Approximately: 4'3" x 2'4" x 1'8"

BACK COVER
Contemporary Gallery 33, photo by Sergio Gómez.
Fue un sueño, tan solo un sueño (detail), 2013, photo by Tim Arroyo.

Published by Editorial **El BéIsMAn**

©2014 by Alfonso Piloto Nieves Ruiz

©2014 Editorial **El BéIsMAn**

Printed in China

ISBN 978-1-4675-8608-5

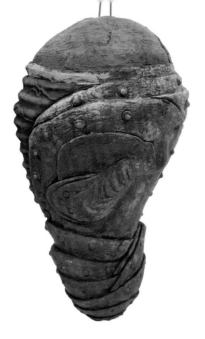

TABLE OF CONTENTS

An artist works in the solitary atmosphere of his studio, but artwork without dialogue from the observer is lost in the void. Art is a complex discipline and, to a large extent, each observer creates his own interpretation. Working on this book has been a collaborative effort that required the participation of photographers Tim Arroyo and Magda Marczewska, as well as writers from diverse disciplines. Kari Lydersen brings us the artwork of Piloto from a journalist's angle and Sergio Gómez writes from the perspective of a curator and an artist, while Brenda Bautista writes from the school of philosophy. I would also like to thank the translators, Diana Hinojosa and Jorge Montiel. This book wouldn't have been possible without the support of numerous friends who donated their time and financial support. To all of them thank you, and especially to Alfonso Piloto Nieves Ruiz, his wife Emily, and their son Río.

~F.P.

METAMORPHOSIS
IN THE SCULPTED WORKS OF PILOTO

~ Francisco Piña ~

Alfonso Piloto Nieves Ruiz's sculptures are molded with the substance of life. As a creative force, he does not seek, but rather dreams, evokes, errs, and finds. His sculptures can be taken for devils, cherubs, or even satyrs; however, his clay figures can easily morph from vile to virtuous, and vice-versa. They seem to cohabit an earthly pandemonium that is all too human. His pieces, made of clay and iron rods, grow and fit nicely into the tree of life that is ultimately characterized by death. With roots, cement, rebars, chains, feathers and plastic bottles, he brings to life an entire zoology of creatures which serve to remind us of that part of the human condition that is dark and not always pleasant. Nevertheless, his work is not fatalistic. Yet redemption is not absent from Piloto's work but, rather, ever-present.

His collection of work is a testament of our time. It is clear proof of a culture of consumption and excess. It is post-modern Baroque and irrefutable proof of poetry that stirs but also maims.

Piloto's sculptures rebuke what the collective body ignores. In the act of transforming the clay into a figurine, Piloto accentuates time and turns it into something that you can see and touch. He brings it to life and gives it vitality. The dreams of this demiurge materialize in his creations. His work has to do more with the realm of the senses than that of philosophical reflection. It is intuition and impulse, where the past and present converge and meet.

His work is transgressive in nature. It transgresses both harmony and good conscience. It's "too much," some might say, but that attests to the shallowness of the spectator. Piloto captures the attention of the observer and does not let him go. Instead, he places the spectator in front of a mirror. Borges was correct in saying that mirrors are abominable, since they multiply the number

of men. Perhaps that is why Piloto questions and rattles the spectator. He rightfully perceived that in the act of trying to fill someone else's shoes and responding to the moral imperative as well as to religious customs, the spectator ceases to be him/herself. That is the internal struggle that surfaces in Piloto's work: the act of becoming while on a pain-ridden path. But not all of his work is characterized by solemnity, much of it abounds with humor.

Piloto stumbled upon his creative process more by accident than by calling. After a long night filled with conversation and debate among friends, he went for a walk on a sunny spring day in Chicago, when something caught his eye. It was under a bridge that he saw the remains of a pigeon between the lines that divide the sun's rays from the shadows. A swarm of ants preyed upon the bird's remains. Piloto rescued its torn wings and returned to his apartment where he decided to return some dignity to the wings that would later form a part of a sculpture. At that point he understood that, *"dentro de todo lo gacho, hay algo chido"* ("inside of everything bad, there is something good"). And that was the first assemblage of an extensive collection that has been in the works, in a compulsive, creative fashion, for almost three lustrums.

Piloto forged his artistic identity autodidactically. His style is akin to baroque, which he observed at the church of Santa Rosa de Viterbo in Querétaro, the city where he was born. However, he also took in the surroundings in which he grew up. He lived a short two kilometers from the city dump. He walked the streets of the neighborhood known as Satélite with closed fists, ready to engage in disputes over neighborhood territories, as fist fights were the only way to win them. As a child, he was nourished with an iconoclastic spirit, taking apart home appliances only to reconstruct them later. He played with nuts and bolts, but also with garbage.

Without even having read Stevenson, he would have adhered to the adage, which states that, "he who does not have the capacity to learn on the street, will much less be able to learn in the classroom." Although school was never his cup of tea, music and sports were and these interests allowed him to keep his head above water for some time. However, due to a head injury, he was forced to abandon sports, music, and finally Mexico.

Piloto immigrated to Chicago in 1997. What was supposed to be a short stay turned into a prolonged and definitive one. In the Windy City he joined the work force in the food service sector. He was a "jack of all trades": busboy, runner, cook and waiter. Once enrolled at Truman College, under the tutelage of José García, he stopped firing pots and vessels, and started freely exploring with *papier-mâché* and clay. Creating became a challenge, considering the constant struggle with partying and work: "I would allow my partying to get the best of me, but the drumming continued to echo in my head." The echo was produced by the drumming he heard in the Native American ceremonies in which he took part. When he participated in the Sun Dance upon the invitation of his cousin Tomás, Piloto had a revelation. More than a revelation it was a discovery that allowed him to see that he was not an end in and of himself, but rather an infinitesimal part of the universe. He came into contact with nature and felt his bare feet caress the earth beneath them, as a child who caresses his mother. He then understood that, "one needs to be in tune with what one feels more so than with what one thinks. If you are not yourself, you will never get anywhere."

For many years Piloto never "got" anywhere. Between actions and words was an abyss that lasted for about one lustrum. His work prior to the fire which burned down his apartment building in 2007 is a reflection of the crudeness of materials and lack of dedication. They are expressive pieces, sprinkled with a certain amount of late surrealism. They are also saturated pieces; what they lack in moderation, they do not lack in imagination. These early pieces not only manifest a certain rancor, but also an open wound that simply

refuses to heal. Piloto bespatters and tears at his own creations. He curses the establishment, but lends a deaf ear to his own existential condition. There is an overwhelming feeling of nonconformity and being fed up. For a moment, he interrupts his creative process to breathe and think: "we go through life like birds and butterflies: migrating by necessity." He became involved in the pro-immigrant march of 2006 and arrived at Union Park with a monumental Statue of Liberty. Between the indignation brought on by a broken immigration system and the babble, there exists a political satire. His criticisms are subtle and he laughs at just about everything.

His studio burned down at the end of 2007, but from the ashes arose a phoenix once again. Piloto began to withdraw from the world in order to become closer to his own self, and that is when he discovered that art was his calling. He began to create from a different perspective, as though he had returned from a place of loathing and begun a dialogue with his inner ghosts. If Piloto forged his artistic identity autodidactically, a few years later he explored and took his work from surrealism, to expressionism and to hyperrealism.

In the end, he would opt to separate himself from any "isms." His school is life: to feel the clay, and to trace roots with his eyes and his senses, to give use to waste and garbage. He creates ideas and transmits emotions, often times in a manner not so sublime, since reality is not always beautiful. With his sculptures, Piloto awakens consciousness without the intent of moralizing.

Piloto is not the first nor the last artist to work with garbage or discarded found objects, but he is definitely one of the most notable representatives of the current "recycled art" movement. Nonetheless, amongst such creators, he is one of the few who opted for sculpture. The generations of Mexican and Mexican-American artists who arrived or sprang up before him for the most part painted on canvas, made prints or painted murals.

Piloto belongs to a generation that arrived in Chicago at the close of the millennium and saw the wake of another century here. His contemporaries are painters such as Alma Domínguez, Roy Villalobos, Laura Gómez, the illustrator Emmanuel L. White Eagle and another sculptor, José Terrazas, to name a few. It is curious that in Mexican Art history, in Chicago as well as in Mexico, the majority of artists are dedicated to painting, making prints and collages, drawing, and recently, making installations. It was Octavio Paz who shed light on the fact that despite the metalworking traditions in

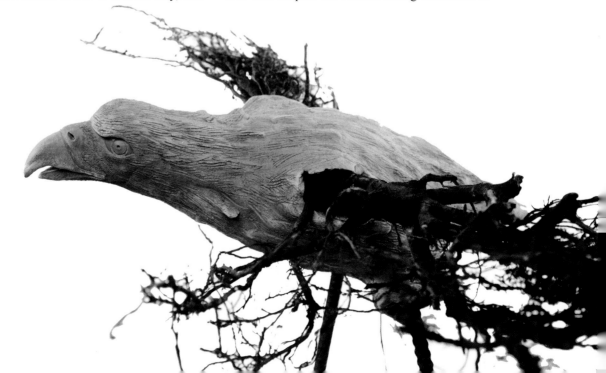

Mexico over the last millennium, there are not many prominent sculptors in the country. Now the same scenario applies to Mexican and Mexican-American artists in Chicago and the rest of the United States.

Piloto is a Mexican sculptor who, like many other immigrants, found his homeland when he left it. His roots were strengthened when he saw them from afar. So thanks to having migrated, he was able to find not only Mexico, but also his calling. It is likely that he would not have explored his creative side had he not emigrated.

Now, Piloto's work is not an exaltation of Mexican nationalism. However, it takes certain elements from pre-Columbian art, but once he touches on them they undergo a transformation. He does not pretend to extol extinct cultures nor exalt iconographies or calendars. His leitmotif transcends borders. It is universal. He is likely to stir the sensibilities of a Pole from Kraków as much as those of a fellow countryman from Iztapalapa. His work has been exhibited at the National Museum of Mexican Art, but has also been well received at the botanical gardens of Garfield Park. In the latter, his sculpture, *Tonantzin,* boasted an air of splendor. In part, it corroborated Mike Davis' idea: "the tropicalization of the United States, but it also catered to certain markets in the United States, while being ecologically conscious and embracing the idea that any object that has been thrown away can serve some kind of new purpose. In many dumps across Latin America, items are found and then reclaimed. Piloto also likes to rescue trinkets he finds in the garbage and then recycle them. It is another way to live in communion with Mother Earth. The artist is well aware of the fact that we are only passing through in this life, and why not do it the best way possible?

It is worth mentioning that there is no poverty in the language of Piloto's sculptures. He has managed to splendidly sculpt empty volumes filled with noise. He does not intend to reproduce contemporary chaos, but rather to give order within the confines of his work. He is able to assemble and synthesize the cultural contradictions of post-industrialist cities. At times, he achieves this with sarcasm, and other times he does so in a subtle way.

After having gotten so close to the work of Piloto, I cannot help but question, "In what way has the progress of the average citizen been beneficial if we continue to live in a world plagued by *injustice,* where the value of *truth* is ignored, and *beauty* is but a concept whose price is set by museums and galleries?" Piloto's work does not hold the answer; however, it is an invitation to the dialogue that will surely continue on with the passing of years and the permanence of his artistic achievement.

Translated by Diana Hinojosa

THE NATURAL CIRCLE OF LIFE

~ Kari Lydersen ~

"I had a dream," says Alfonso Piloto Nieves Ruiz, picking through lumps of clay and piles of plastic bags and refuse collected in his basement.

"But not like Martin Luther King Jr.," he finishes, jokingly.

Piloto's recent dream had him buried up to his neck, just his face exposed, as "desperate" creatures part maggot, part horse, part human crawled all around him—maggot bodies with the forelegs of horses and grimacing human faces, bridles emerging from their skulls and held tight in their mouths, blinders on their eyes and nails in their ears. "So they couldn't hear anything and they could only see straight ahead," says Piloto, handling an intricate clay replica of one of the dream creatures—part of a massive in-the-works sculpture. Though the image might sound simply surreal, there is much deeper significance to it, of the type that runs through most of Piloto's works and through his own life and psyche.

That would be the struggle to buck the pressures of conformity, peer pressure, materialism, an obsession with "going for goals that aren't really you," Piloto says. His work is infused with representations of this struggle on both a personal, corporal scale and also a societal level, where the aforementioned forces lead to environmental destruction and social despair; while the idea of rejecting the pressures and embracing the natural and metaphysical world offers an antidote.

In the dream-inspired sculpture, some of the maggot-like creatures have dropped their bridles and blinders and instead have grizzled faces lifted rapturously to the sky, as their backs split open—another common image in

Piloto's work—to reveal the vast beauty of the Milky Way. "They're calm, they're relaxed," notes Piloto. "They've seen the light."

Piloto feels like he saw the light himself in 2007 after a devastating fire in his Pilsen studio destroyed all of his sculptures.

"After the fire I realized most of what I lost was material. It made me think, 'What am I doing here?' I came"—presumably to the U.S. from Mexico, and more generally to that spot in his life—"for all this material stuff and then suddenly it just burns."

Piloto grew up in an impoverished colonia in Querétaro, government housing built on the edge of a maquiladora factory zone. The gleaming factories for multinational companies formed the backdrop of his young existence. In the colonia where many of the workers lived, there was no running water. He remembers going to the latrines in the night with a flashlight, confronting rats. People would sell milk from goats, and steal pipes for the lead and copper, struggling to survive however they could. A festering garbage dump was just two kilometers away. And the river near the colonia was like a dump too—factories spilling toxic waste into it. "At midnight they would release gases," he remembers. "You'd hear loud sounds, and start smelling something weird and then tasting it. In the morning your mouth would taste terrible." Kids sniffed glue and there were lots of fights. At the time it just seemed normal—"you don't know anything different."

Later he would realize how the maquilas and the colonias were part of the global system of materialism and capitalism that physically, emotionally and socially enslaves people from the impoverished workers on up to the consumers driven to always buy, use and discard.

Piloto made his way to the U.S. and Chicago in 1997, to see his friends' rock band play in Milwaukee. But a head injury thwarted his plans of continuing to play and coach American football in Mexico, so he was looking for new direction and opportunity. With almost no formal training, he began to make his name as an artist, building art out of the waste and discards he found around him in Chicago, inspired by his experience in two countries and multiple overlapping cultures and environments. Plastic, metal, concrete, rebar. Twisted wires, lost feathers, goat skulls from *birrerías*. Rusted cogs and nails, broken electronics.

The sculptures are disturbing and riveting, they make your stomach turn and give you chills, yet you can't turn away. The discomfort is in part because the images tap feelings of guilt and self-loathing in the viewer, probing the ways that we are all petty and greedy and compromised by the society in which we live. Piloto admits he can't fully escape himself the very system he attacks. He tries to live sustainably, but still his family ends up with mounds of plastic and garbage. It's a world where you are confronted with things like "diapers, two bags for an avocado," constantly during daily life—though Piloto personally reuses plastic bags and refuses double-bagging.

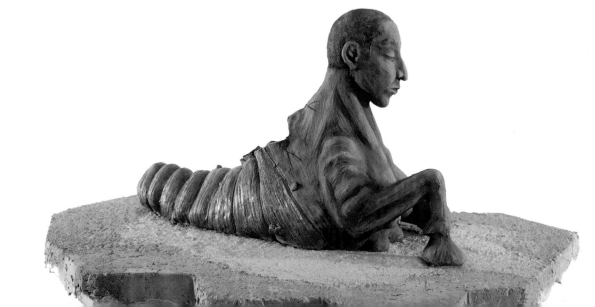

"There's all the poison and toxic waste affecting us, not only the physical, but the spiritual," he notes, driven in part by "all the new necessities they invent for us," which he says wryly as he flips through images on his iPad. "Now everything is disposable, and they want to sell you the warranty. As soon as we got knowledge and fear, we started creating more things, more things, more things."

A symbol of the hypnotizing, dehumanizing pull of materialist ambition is the worms crawling around a deep hole in one work. Only one enlightened worm is calmly going in a circle that will lead him out of the pit—the natural circle of life. The others are misguidedly trying to construct shortcuts, then slipping and tumbling on top of each other and down into the void.

The cycle of consumption is captured literally and figuratively in Piloto's piece "Hambriento," where a bloated ogre of a man morphs into a cow and pig, gorging themselves at a trough on the transgenic corn that has replaced the maize which had deep spiritual and cultural meaning in Latin America. Genetically modified corn grown and consumed on mass scales transforms from life-giving to spiritually and physically polluting. "We're all like that now, since we are what we eat," Piloto says with his resigned humor. "We've made these animals like machines."

But Piloto's works offer us an out, a hint that it is not our fault and it is within our power to choose another path. A recurring theme is people trapped—trapped by social constructs, trapped within their own bodies and brains, trapped by fences and bars and chains and bricks. Literally, in his sculptures which feature countless beings within beings, body parts transform-

ing seamlessly into whole bodies or animals or machines. "The Addict" is sleeping on his own tongue—"very comfortable there," his heart full of eyeless maggots, pleasantly blinded and numbed to the realities and possibilities of life.

And yet usually there is a way out, as with the mutant worms in the dream-sculpture dropping their bridles and splitting open their bodies. There are zippers that can be opened, walls that can be broken down and fetters that can be shed.

In this vein is the piece with the play-on-words title: "Para de-formar gente." It can mean essentially "for deforming people," or "stop forming people." There are the heads of a young boy, an adult, an old man. The boy has wings attached to his head with plastic ties, but fists are coming out of his eyes. He's "always being told 'no,' preparing him to be one more worker for the big guys." As an adult, his head will be full of bricks. But they can be removed.

"You're the director of your own life, if you don't like your role you can change it," Piloto says. "We don't have long, so we have to be conscious of our surroundings and live it well."

Piloto's work was always political and provocative, but after the fire it took on a new level of introspection, and a sense of peace, acceptance and growth coexisting with and ultimately seeming to triumph over the disgust and rage. He was letting go of the anger he realized he'd been harboring, and contemplating the connections between all living things and the threads of continuity through human and natural existence.

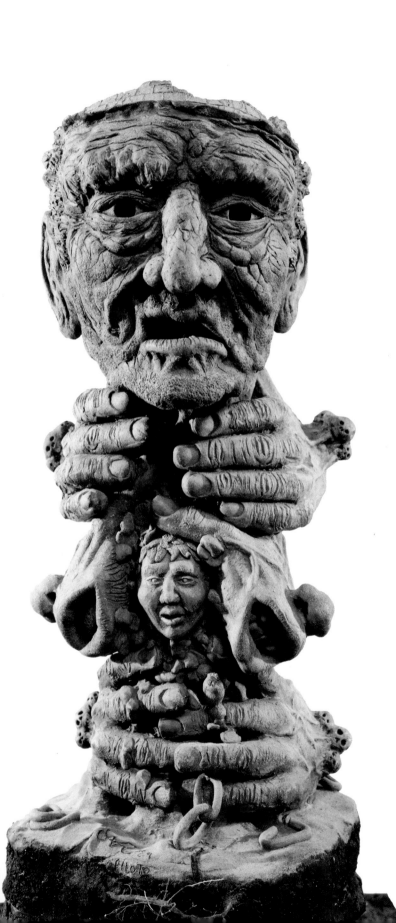

Throughout his works are woven strands of DNA, cycles of sunset and sunrise, the gravitational pull of the sun and the moon. Roots, providing grounding and offering a path back to the origins, just when people seem at their most detached and depraved. Leaves and new branches, reaching for the heavens and offering the chance for transcendence.

Within the few years after the fire Piloto stopped drinking and partying, got married and had a son, Río, born in September 2011. His wife Emily, a high school Latin American history and Spanish teacher, notes that his sculptures have gotten more hopeful and less dark since Río's birth. A perfect example is Tonantzin, his rendering of the Aztec Mother Earth figure.

Her body is modeled on Emily at 38 weeks pregnant, with the belly painted as a globe. Tonantzin's clay and concrete cast face is painted red and black, colors more commonly meant for male priests and warriors—representing the duality of gender, the way we are all both male and female. A web of bright rivers spread over her voluptuous, bare chest, celebrating the ritual of breastfeeding, even as many Americans are "disgusted" by the site of a woman nursing her child in public.

And while the traditional image of Tonantzin depicts her giving birth to a skull—indicating the circle of life and death—Piloto puts a more life-affirming spin on it with a garland of ruffled orange flowers fixed to her crotch.

"We say when we die we flourish," Piloto muses. "Life is like a stage—we can experiment with the physical form, but we have to die. Then like a seed disintegrates in the ground, the cycle continues…We all share the same elements, the same metals. We all started from the big bang, from that energy. We are energy…And the life that we live is our greatest work of art."

THE TRANSFIGURATION
OF ALFONSO PILOTO NIEVES RUIZ

~ Sergio Gómez ~

*I would feel more optimistic about a bright future for man
if he spent less time proving that he can outwit Nature and
more time tasting her sweetness and respecting her seniority.*

~Elwyn Brooks White, *Essays of E.B. White,* 1977

Without a doubt, the debate over the impact of our human footprint on this planet has never been as important as it is now. Not only the effects of pollution but also the poisoning of the food chain have created a world in peril. Unless the present generations learn to respect the Earth's seniority, our future is not an optimistic one. Although the Earth cannot speak for itself, it has an active spokesman in artist Alfonso Piloto Nieves Ruiz. The Earth has found a warrior, a survivor, an inventor and an advocate whose innate nature appears to have embraced the call for justice. In his work, Piloto lifts up a cry of pain on Earth's behalf and, with a gifted touch, creates intricate metaphors of the agony of the fight between man and nature. A fight that man began and needs to end.

Piloto is an intense artist on the inside yet humble and friendly on the outside. His candid spirit allows him to engage fervently in conversation, advocating for his work and that of the importance of Earth's conservation. He is a self-taught artist of humble beginnings who began his trajectory in the city of Querétaro, México, playing with dirt, rocks, and found objects. As he made Chicago his new home, art followed him and enlisted his natural gift and visionary mind. Piloto works primarily with clay, giving birth to fantastical figures made of soil and discarded objects. An avid collector of objects, he

finds new meanings for such undesirable goods. In a culture of disposables, Piloto collects, repurposes, recycles and reinvents with the mind of a scientist. For him, these are more than simple objects; they are fascinating remains and physical traces of our contemporary human behavior. Each piece tells its own story through its original purpose. However, in the hands of the artist, each piece embraces a new meaning and a new life. Piloto employs contemporary imagery and objects of mass consumption such as iPods, keyboards or toys combining them with pre-Columbian mythical figures. It is in such rich fusion of cultures and realities that one finds a trace to Piloto's own life story. The past meets the present and warns us about the future.

In the well-known "Unfinished Slaves" sculptural works of renaissance artist Michelangelo Buonarroti, the human forms struggle to escape the stone that they inhabit. They become Herculean forces fighting to be freed from their captive confinement. The extraordinary tension between the massive marble slab and the figure in motion provides an insight into the master's greatness. In such works, the vaguely defined contours of the figure appear to already exist inside the stone as it fights its way into our own world. Such violent force, frozen in time within the solid rock, crumbles away with each of Michelangelo's chiseled strokes. It is known that Michelangelo saw himself as the one liberating the figures that already existed in each stone. Similarly, in the clay works of Piloto exist the presence of ancient figures awakened by the artist's own hand. They appear to emerge from the earth in the form of clay sculptures. Their incredible realistic likenesses slowly emerge from the ground as triumphant warriors.

Many of those figures have already been liberated and abound within our midst. In that sense, the artist once again becomes the liberator of such captured creatures. They seemed to have already existed in the ancient past, but now they see the light of a new reality. In the works of Piloto, figures are often depicted as grotesque, at war, or in agony, whereas other times they are as gentle as a woman playing a violin. There is no doubt that there is a strange and captivating beauty in such mythical figures, an aesthetic that confronts the viewer, yet invites him or her to continue searching for more. In fact, Piloto is a master at this. He incorporates detail and hidden objects in the most confined of spaces. This way, the works entice the viewer to close inspection and scrutiny, only to be surprised by what one finds. These works are not entertaining. Instead, they intrude into our very own psyche by appealing to the otherness within each one of us, that other that often consumes and destroys rather than planting and protecting. They also allude to our social and cultural behavior of disposal of unwanted things. Our garbage tells our story and it takes an artist like Alfonso Piloto Nieves Ruiz to retrieve with horror the truth about what is less desirable about our society.

Piloto's human figures inhabit our world as heroic creatures of ancestral worlds. They are expressive, surreal, highly detailed, full of life, and disenchanted by their agony. At times, they appear to be monstrous with features that would appear as if they just came back from death. They may have two heads, three eyes, and big stomachs or show a ferocity only reserved for those who inhabit the underworld. The realistic appeal of such works confronts the viewer with intensity and engages him or her at every turn. Borrowing from his rich Mexican heritage, Piloto pays homage to the past in the form of symbolic references to the indigenous cultures that inhabited the Americas. In fact, the ancient cultures of the world understood that their survival was strictly connected to their understanding of the land and its natural resources.

If the ambassadors of ancient cultures could come back from the past and engage the present, how would they react to our current decay? In a way, they are already here in the works of Piloto, giving us a glimpse at their dismay, and crying out for justice on Earth's behalf. It is perhaps this distinct connection with the past that enables the artist to be so eloquent with the present. Although his work makes direct references to Latin American ancient cultures, Alfonso provides a universal appeal relevant to all of us. Not only does Piloto acknowledge his past, but he also confronts his present. Aware of the Earth's struggles to flourish freely, the artist looks ahead with optimism and reassurance that there is still time to change the course of history.

As a prophet in a foreign land, Piloto employs what he knows best, his Mexican roots and his art, to make a process that collides with a current culture of mass production that pollutes first and asks questions later. His sensitivity for what is sacred and what is profane allows him to engage in the ecological conversation with passion and reverence. Through his work, Piloto has redeemed the ecosystem and empowered the captive forces of nature to remind us all that balance is achieved by reverence and respect rather than arrogance and control over the natural resources of this beautiful planet we share and inhabit. In the end, from ancient cultures to Piloto, it is in Earth's raw materials that beauty is born.

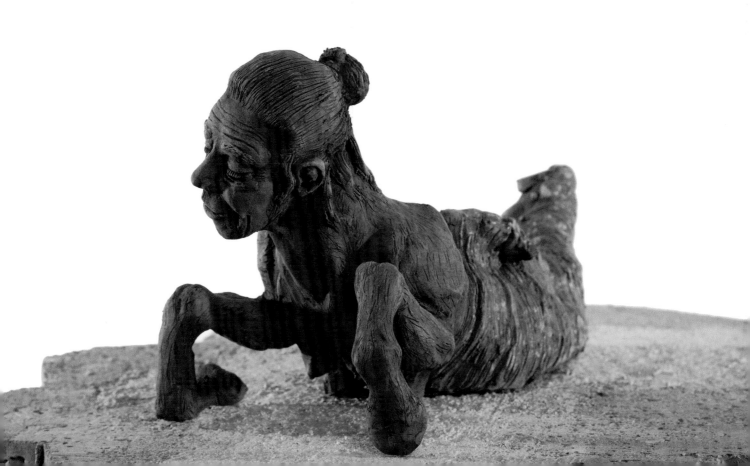

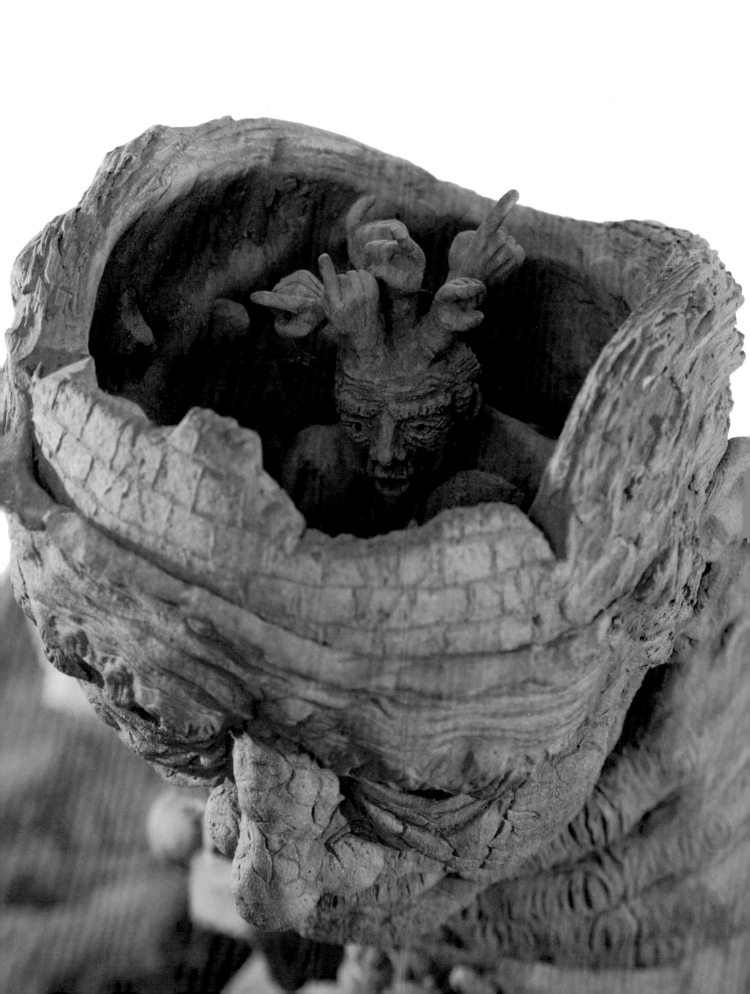

VISCERAL BEING:
THE SHOCK OF THE GROTESQUE

~ Brenda Bautista ~

The creative impulse captures artistic intuition, which demands presence and embodiment, mediating between the real and the divine—a state of being near the mystical ecstasy. Alfoso Piloto Nieves Ruiz's story is similar: beholding his work as a sculptor and listening to the discourse that it embodies calls for a deeper convergence of ethics and aesthetics. The politics, which precede the metaphysics, combine to form a structure, a totality: Life.

What about the antagonistic discourses? Should they be put aside as we come into contact with the work of Piloto? No, the visceral being precedes the shock that results from the grotesqueness, a transgression of the classical ideals of beauty. In this way we enter into a dialogue with the artwork. The subjective and the objective are juxtaposed, one step at a time, following the unconscious and the conscious; contrast after contrast.

Shudder and astonishment arrive, laughter and playfulness, unveiling questions through mirrors and voids in volumes. Piloto's extension of his creativity allows us to participate in reality's metamorphosis. Fantasy unlocks intermingling animals, humans, roots and objects behind which there is invariably a witnessing of the *who*. In his work, the characterization of faces reflects the angst and rootlessness of human beings. Its elements—clay and trash—synthesize the contradiction of being composed of soil, our attachment to which, builds upon a sense of "false belonging."

Piloto carries a diaphanous sight that beholds the world and treasures the proper innocence of free creation. His vision, the use of his art as expression and protest, represents the construction of our circumstances. It aims at deconstructing power and its consequences, and it advocates for re-emphasizing the relationship between ethics and aesthetics: the grotesque as a mirror demonstrating the human being's symbolic death through the stereotypes that distort what should, in fact, be a constant search. The fusion between different bodies of nature exhibits the dismantling of the hierarchical and anthropocentric triangle while it approaches what is alive, which is fundamentally an effort to show that we are all part of the whole.

In Piloto's plastic art there is an ethical proposal and political criticism asking, "Where are we going?" The bodies' tension; the arms, and tongues emerging from orbit-like cavities, the masks and chains, unfinished skulls and heads symbolizing the world of perspectives tell us that, despite certain ways of being in the world which are justified by different idiosyncrasies, human beings are responsible for redirecting their way. One of the paths presented by the artwork at stake is a oneness with Nature, an overturning of (auto)consumerism, and a consciousness of freedom.

Translation by Jorge Montiel

Las alas del caído, 2001
Papier-mâché, wood, wire, acrylic, resin, pigeon carcass
approximately: 6" x 1' x 11"

Ángel caído, 2001
Papier-mâché, wood, nails, wire, acrylic, pigeon carcass
approximately: 1'6" x 1' x 1'4"

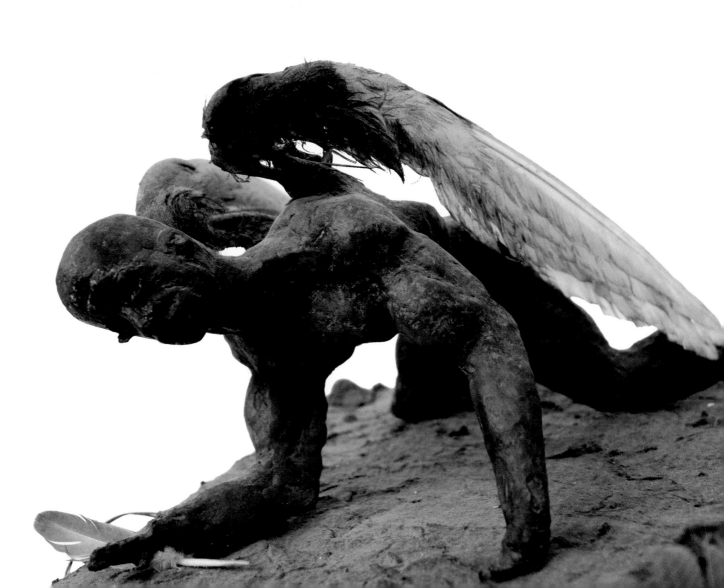

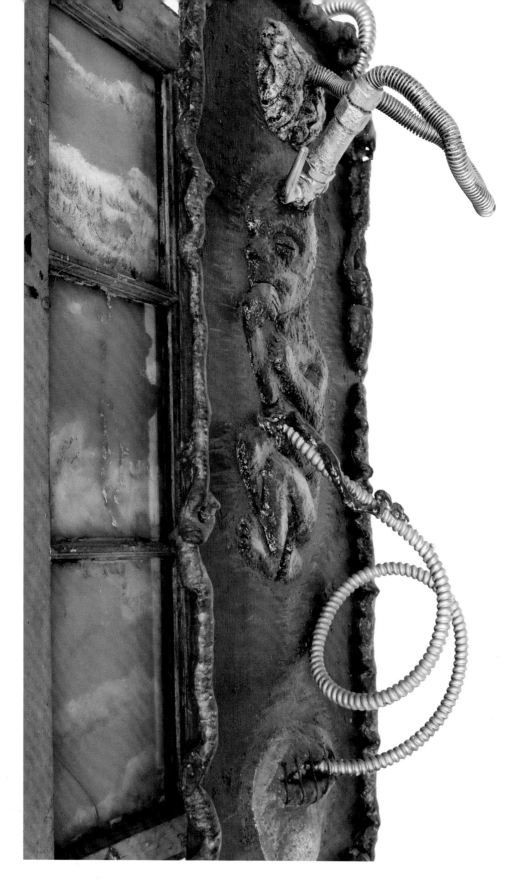

Déjalo ser, 2001
Papier-mâché, wood, nails, wire, foam, acrylic, canvas, found objects
approximately: 3' x 1'4" x 1'3"

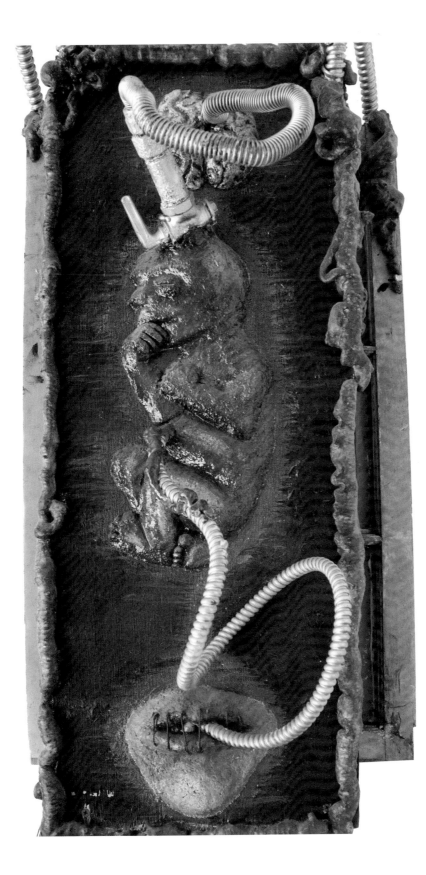

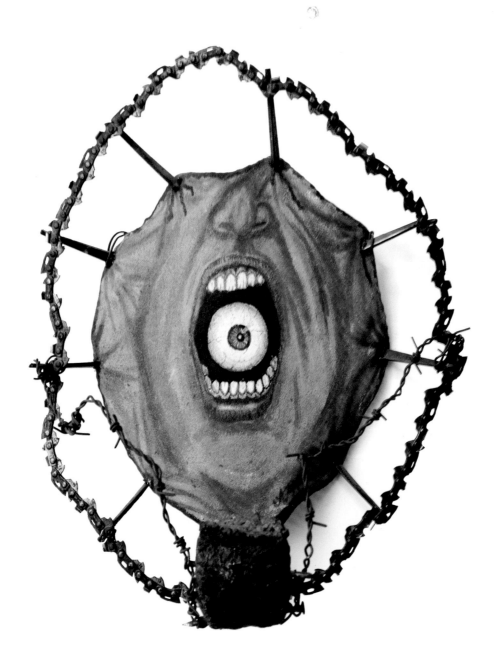

Gritándole injusticia, 2002
Papier-mâché, nails, wire, acrylic, canvas, chain's saw
approximately: 1'1" x 1'1" x 6"

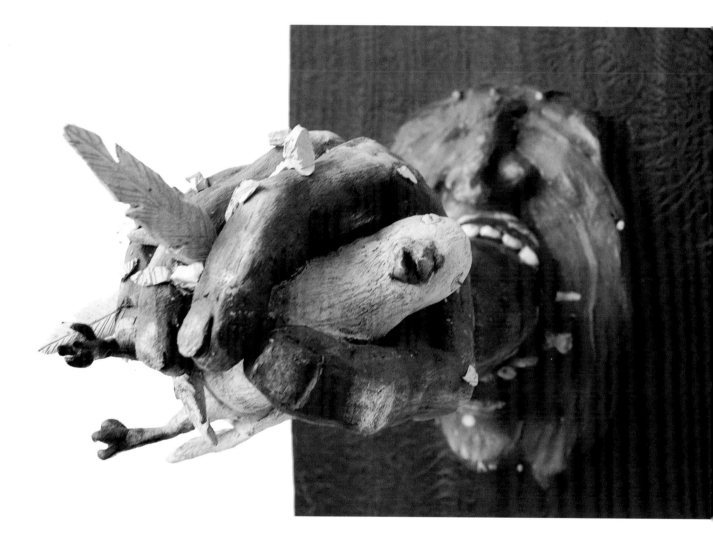

El dictador, 2002
High-fire clay, oxides, wood, nails, acrylic
approximately: 1' x 1'2" x 1'

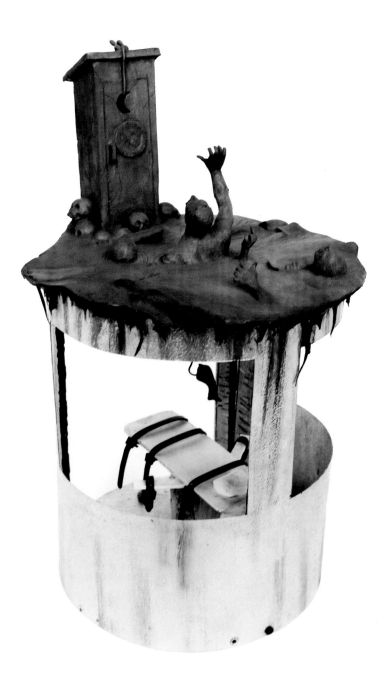

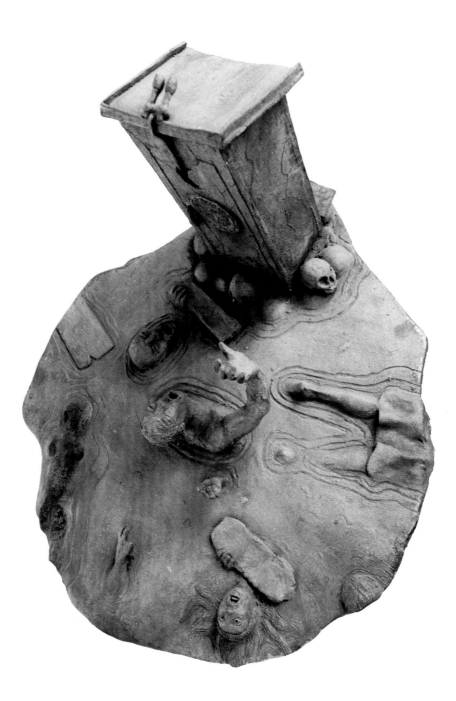

American Dream, 2005
Papier-mâché, high-fire clay, oxides, aluminum, plastic nylon handcuffs, cardboard
approximately: 1'6" x 1' x 1'

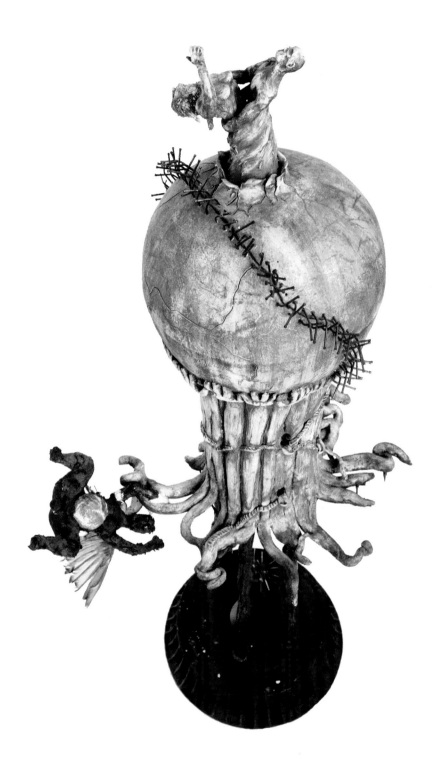

Cerrando la herida, 2005
Papier-mâché, high-fire clay, nails, wire, acrylic, steel drum, rebars, bird carcass
approximately: 3' x 2' x 1'3"

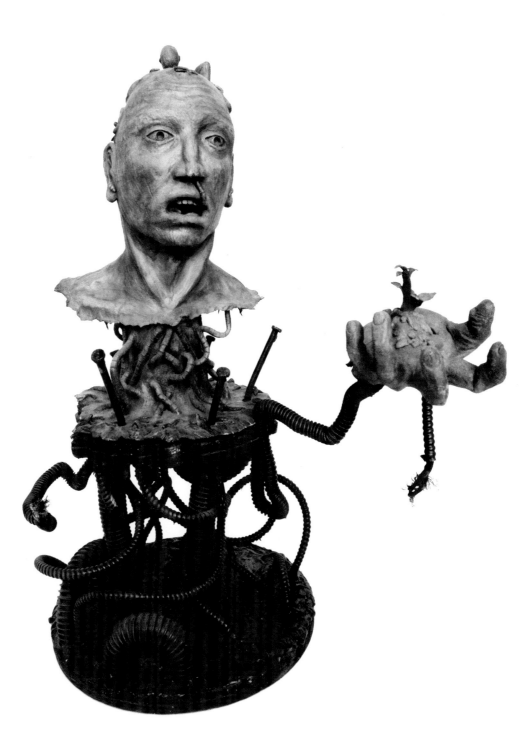

Humanos: pinches gusanos, 2006
Papier-mâché, high-fire clay, oxides, wood, nails, wire, acrylic, electric and plastic pipes
approximately: 3' x 1'8" x 2'

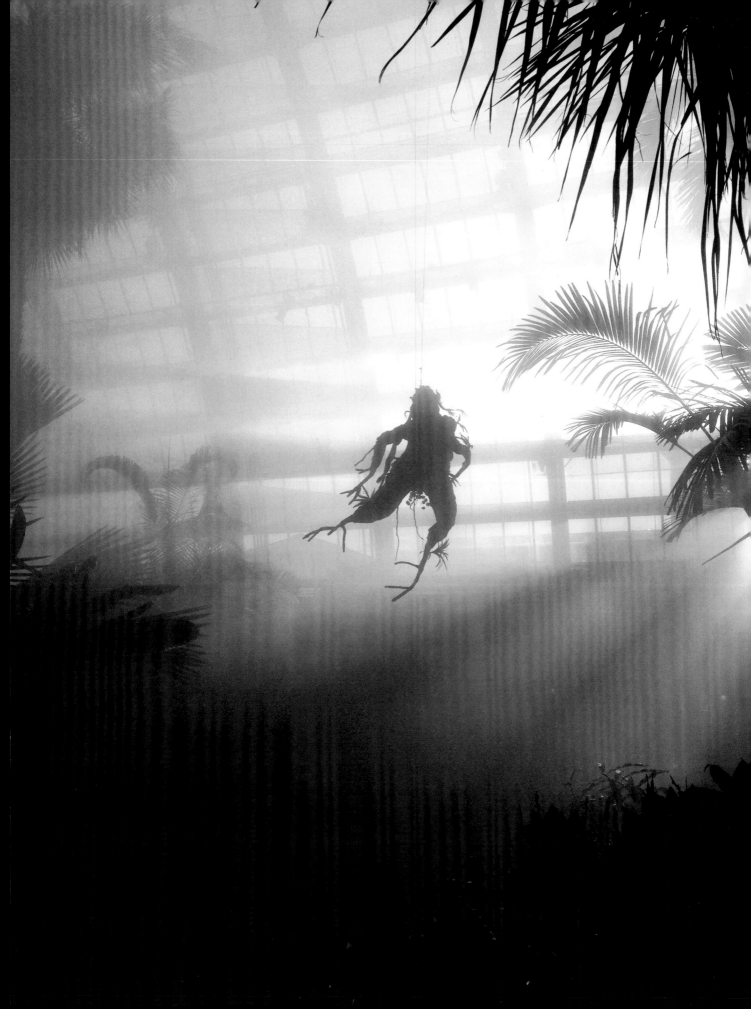

LUSTRUM II

Solo hay una salida (detail), 2008
High-fire clay, oxides, papier-mâché, wood, acrylic, iron pipe, plastic bags
approximately: 2′8″ x 1′3″ x 1′3″

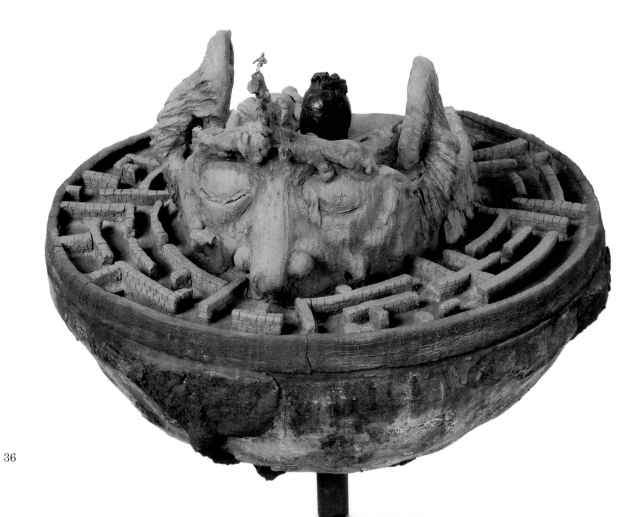

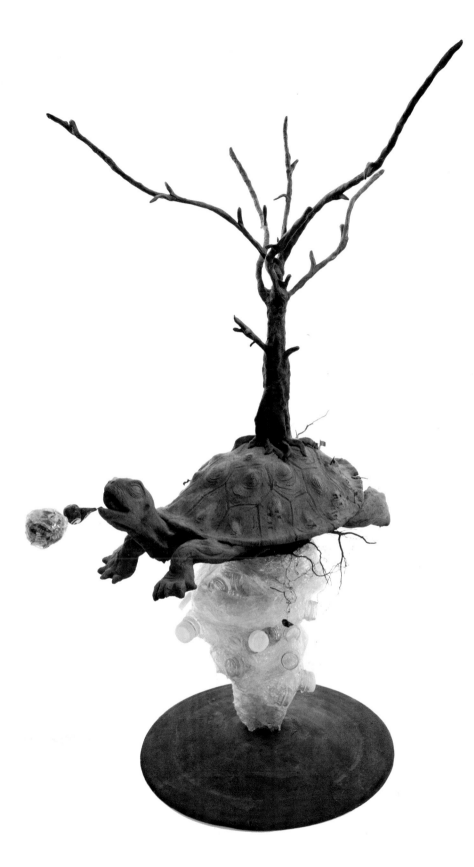

Escucha, 2009
Low-fire clay, oxides, wood, acrylic, rebars, plastic bags and bottles, glue, roots, epoxy, fan base
approximately: 3'8" x 1'11" x 1'3"

Update Your Status, 2010
High-fire clay, wood, acrylic, electronic boards, epoxy, wire, found objects
approximately: 2'9" x 3'9" x 2'2"

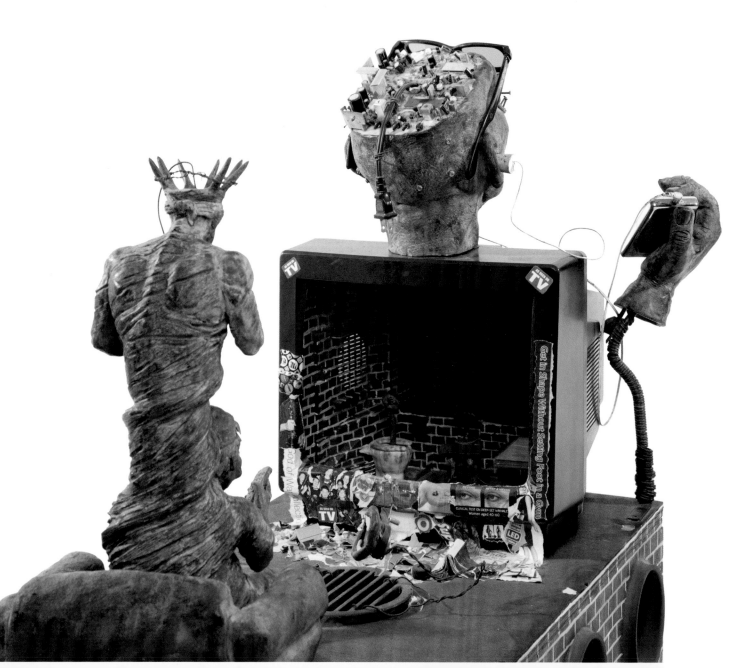

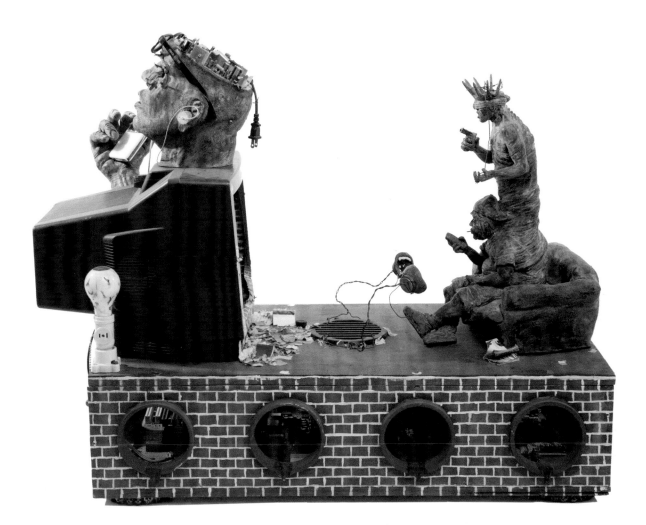

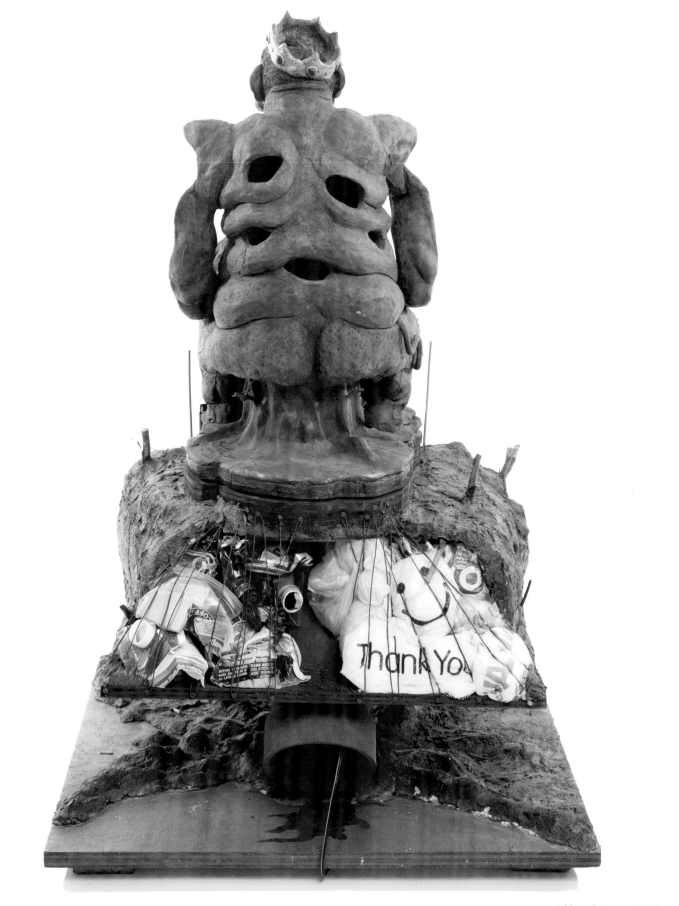

El hambriento, 2010
High-fire clay, wood, acrylic, concrete, wire, nails, found objects, and garbage
approximately: 2'8" x 2' x 2'

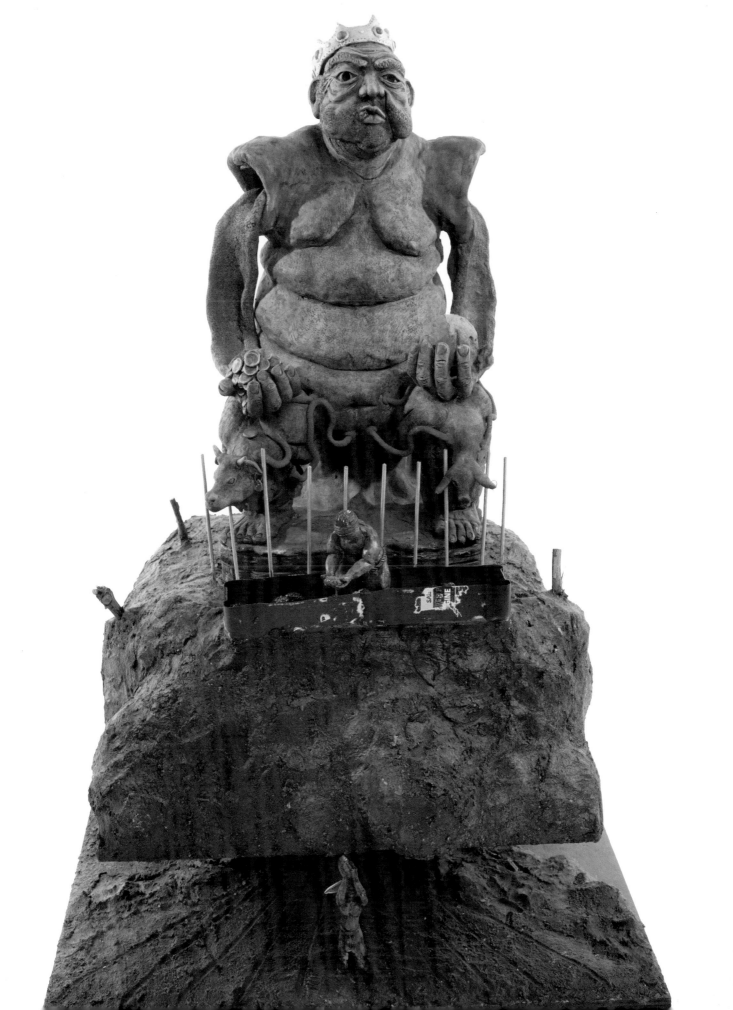

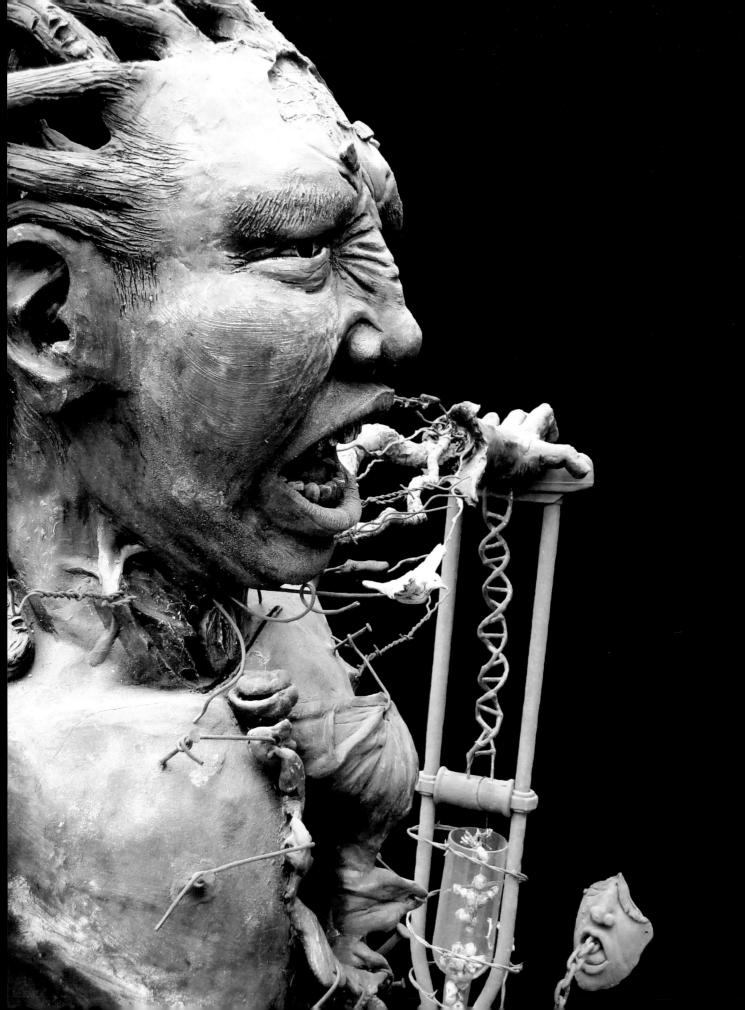

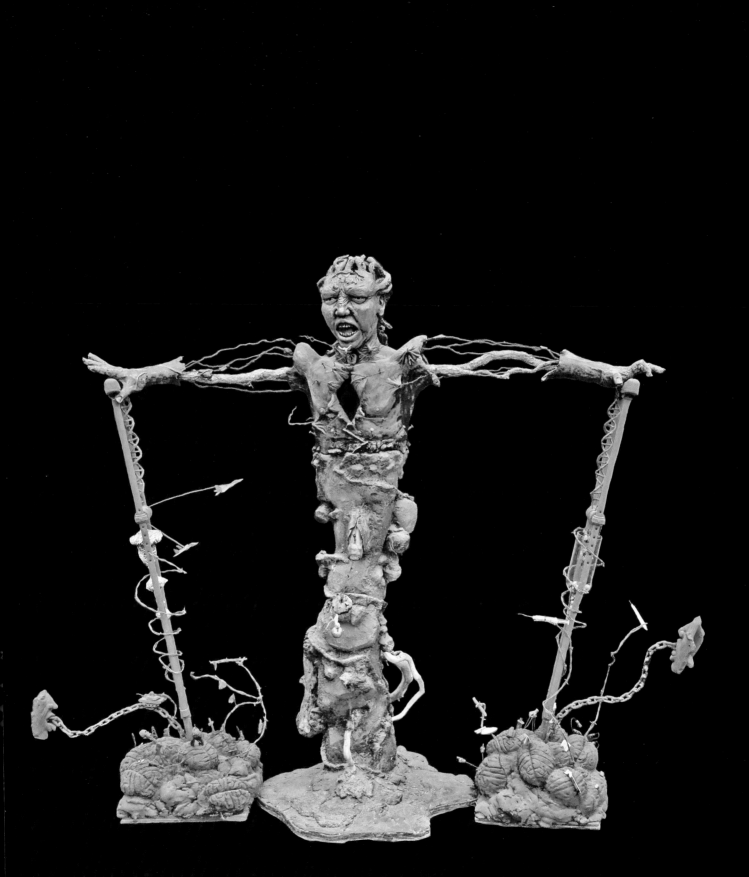

Para regresar a mis raíces no necesito estas pinches muletas, 2008 – 2010
Low-fire clay, wood, acrylic, rebars, papier-mâché, concrete, plastic bags, crutches, roots, and found objects
approximately: 5'5" x 7' x 2'8"

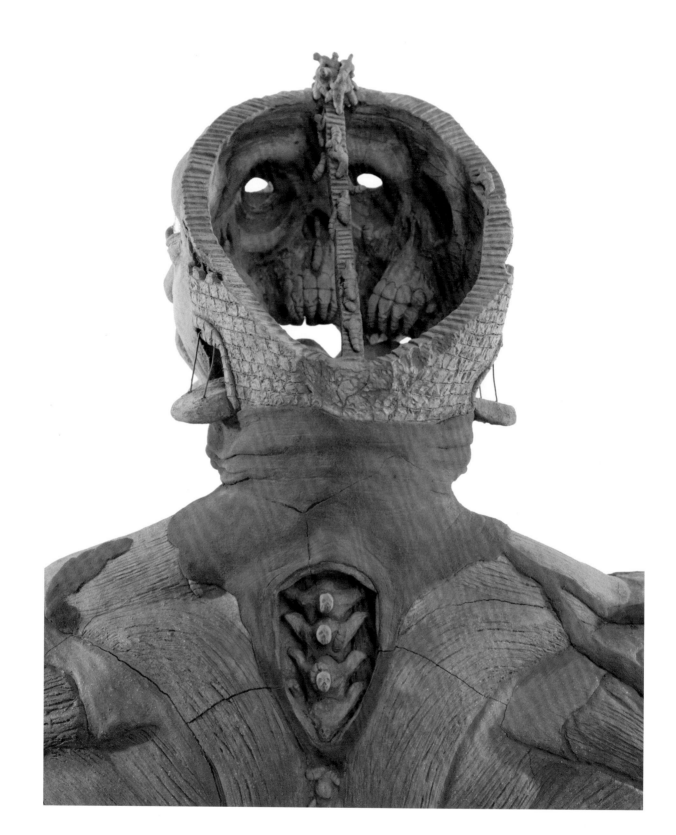

El gusano de la envidia, 2010
High-fire clay, oxides, wood, acrylic, rebars, concrete and plaster, plastic bags
approximately: 4' x 2'4" x 2'2"

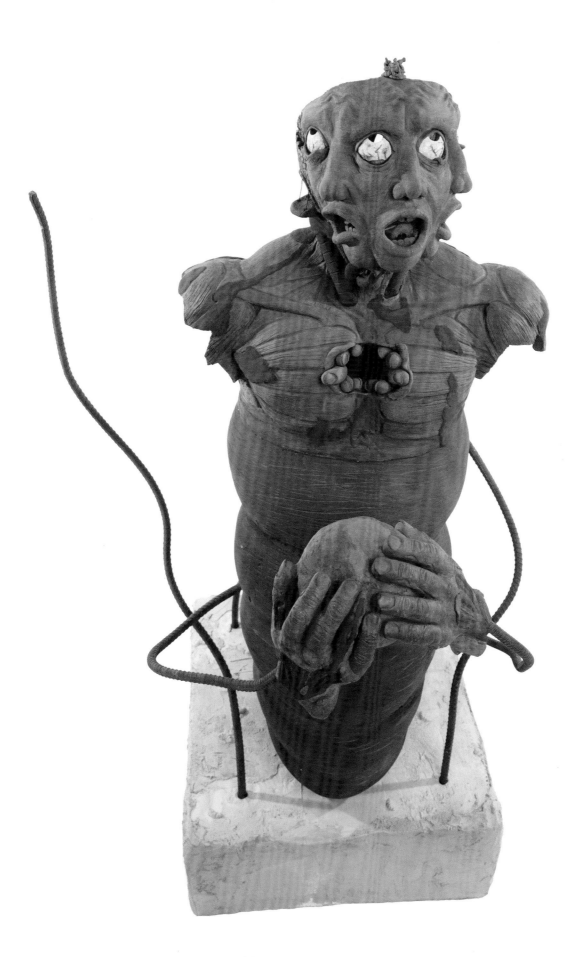

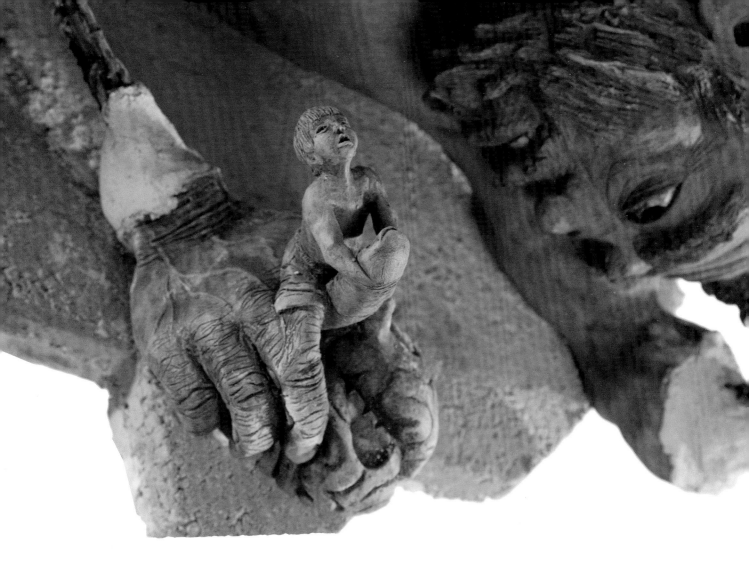

The Addict, 2008 – 2010
Low-fire clay, wood, acrylic, rebars, concrete, chains, plastic bags, auto parts, roots, garbage
approximately: 4' x 2'10" x 1'10"

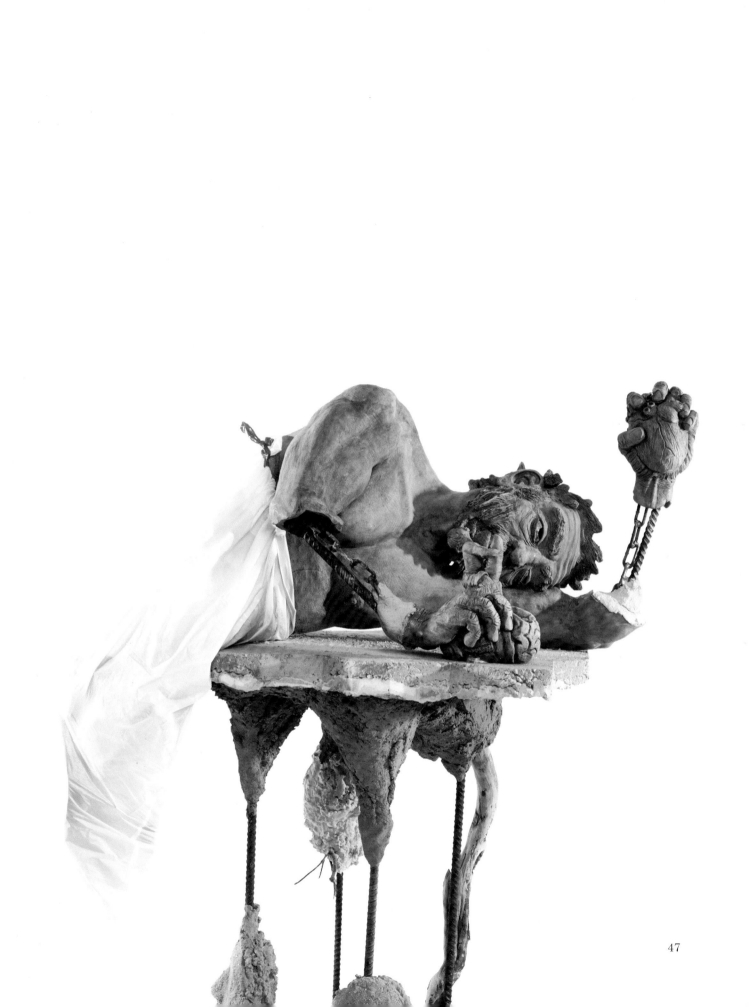

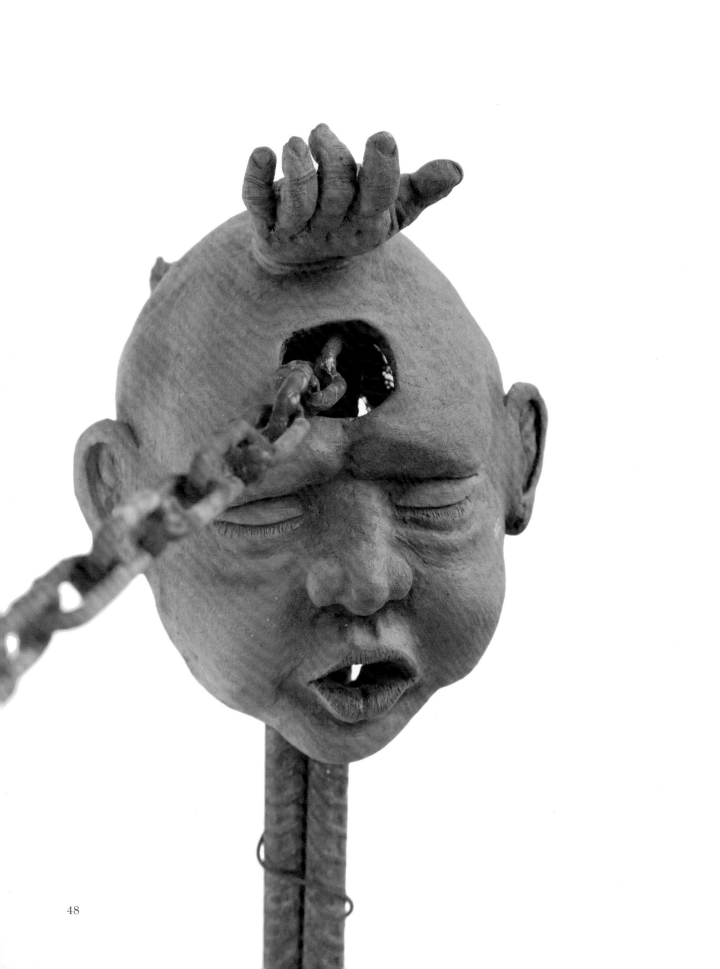

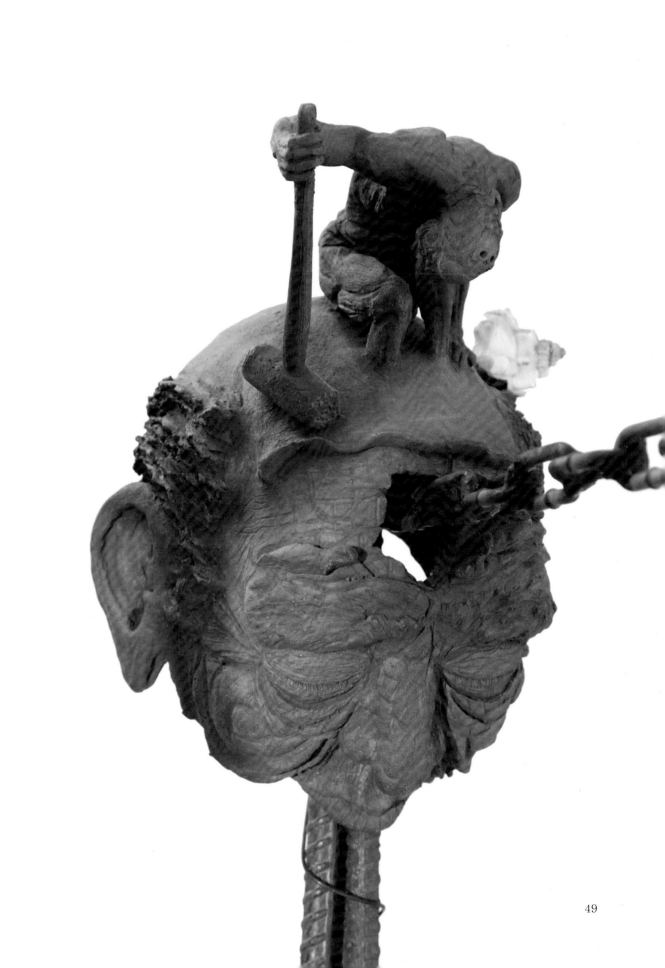

Para de-formar gente, 2008 – 2010
High-fire clay, oxides, epoxy, mirrors, soil, roots, wood, acrylic, rebars, concrete, chains, reclaimed insulation foam, clock
approximately: 5'5" x 2'4" x 2'4"

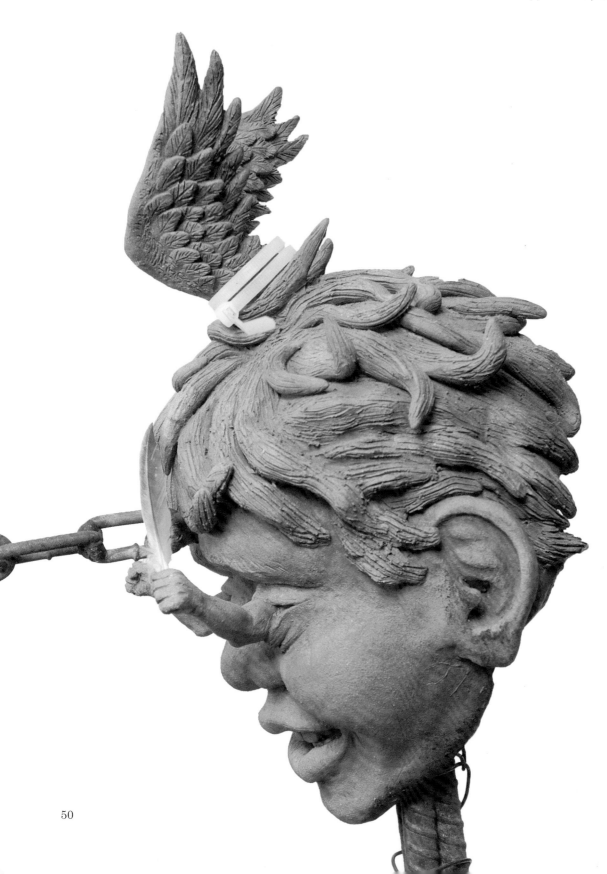

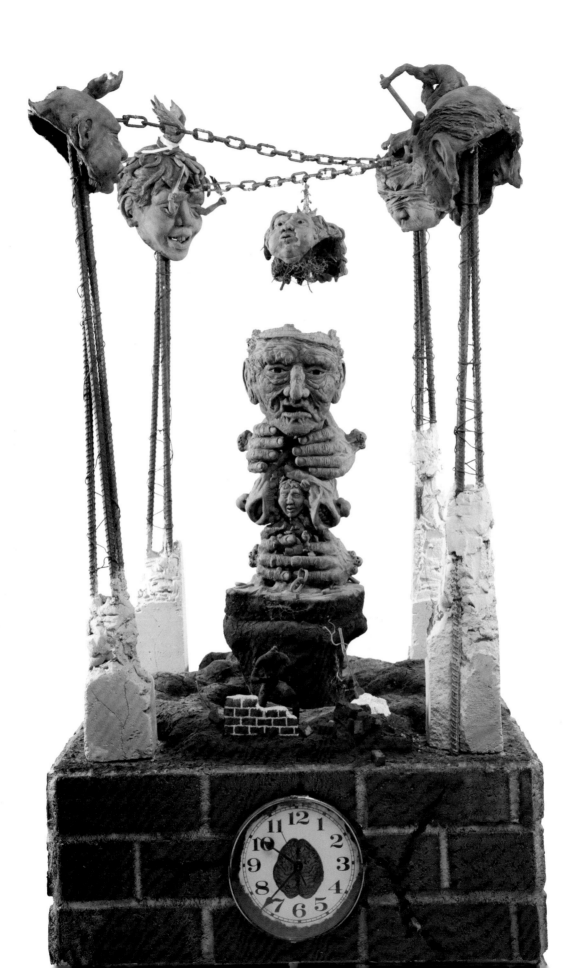

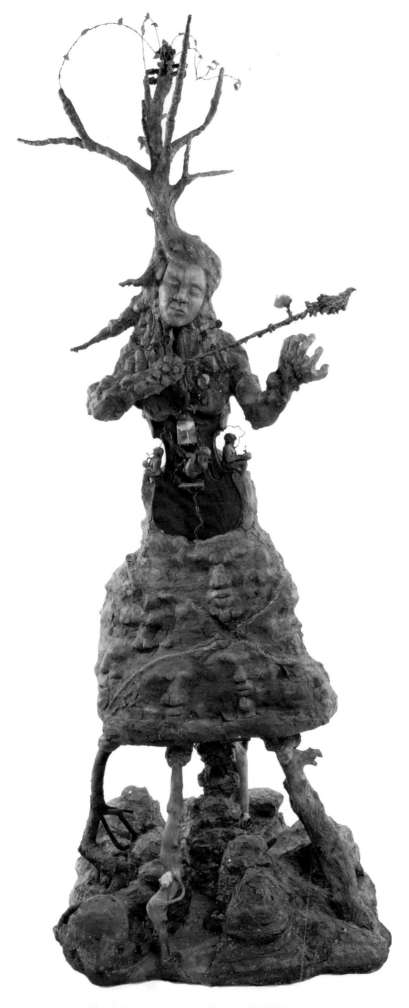

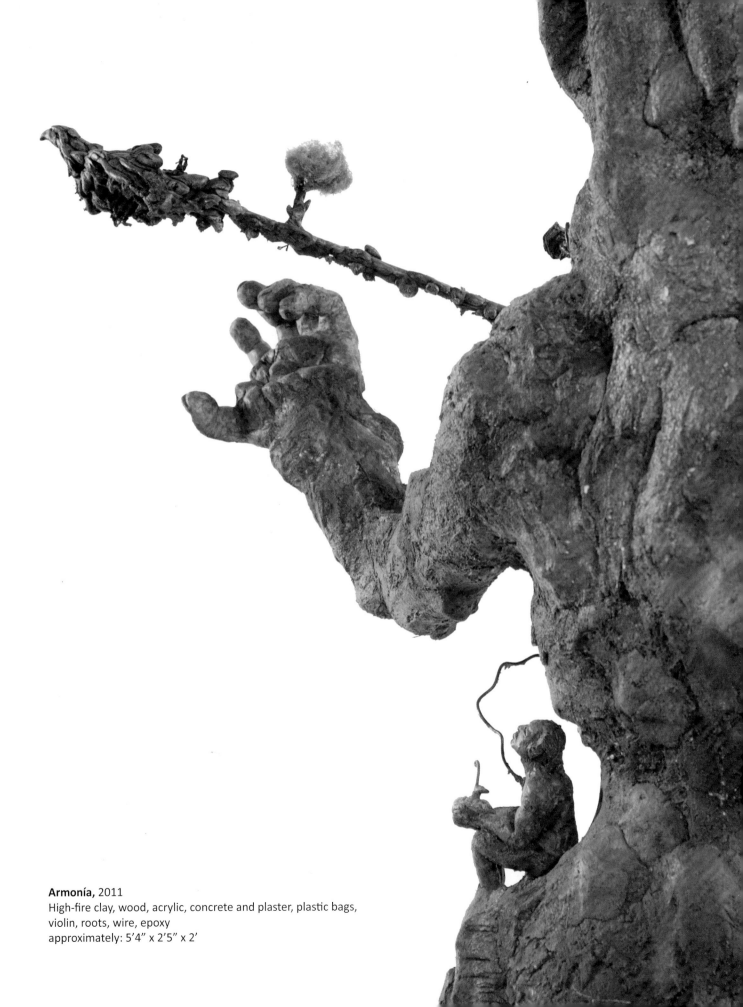

Armonía, 2011
High-fire clay, wood, acrylic, concrete and plaster, plastic bags,
violin, roots, wire, epoxy
approximately: 5'4" x 2'5" x 2'

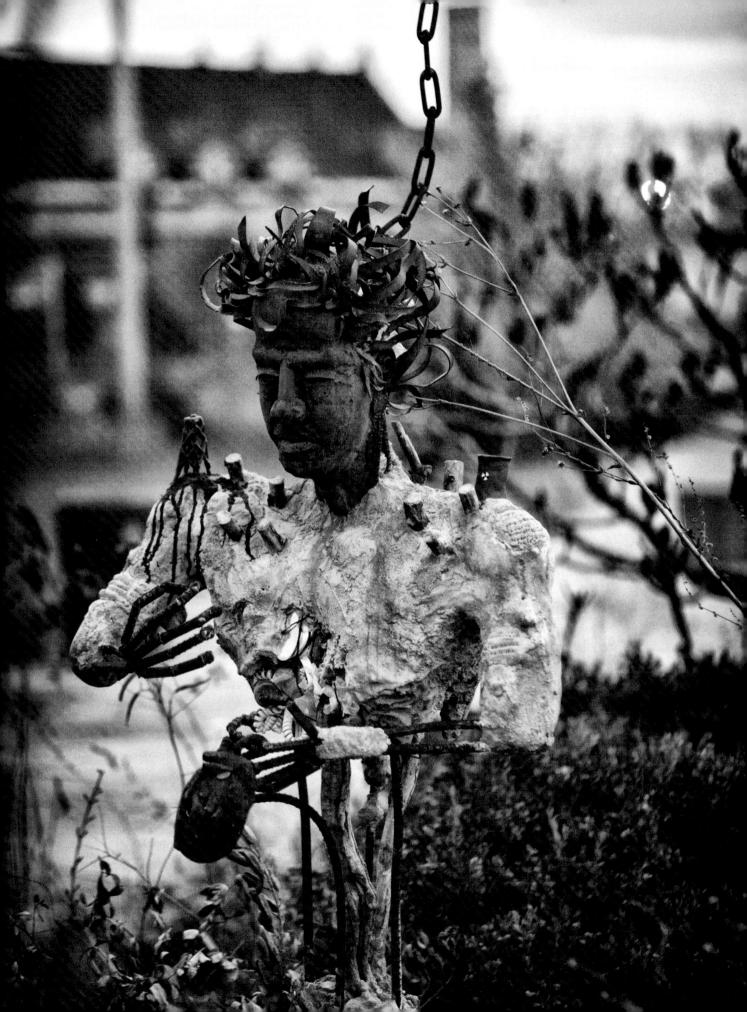

El materialista, 2012
Iron, chains, rebars, concrete, plastic garbage, roots
approximately: 6'3" x 2'10" x 2'10"

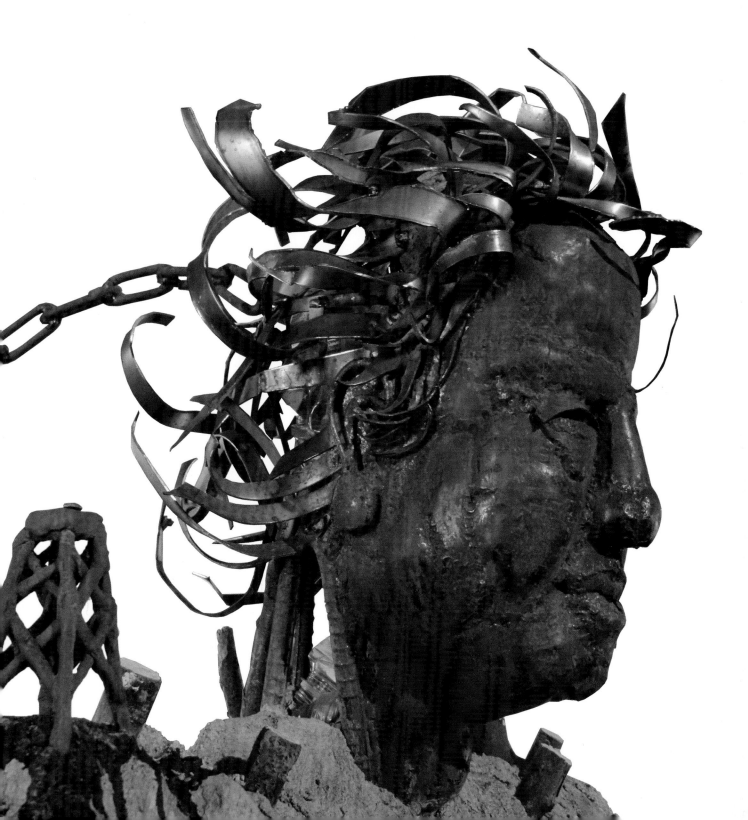

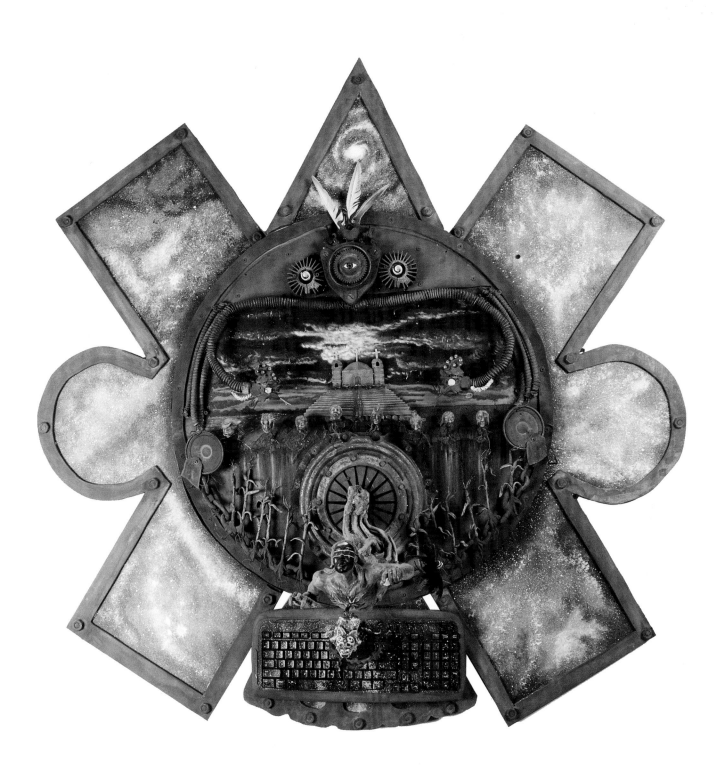

Recuperando la conciencia, 2010
High-fire clay, wood, nails, gas pipes, snake bones, acrylic, chains, epoxy, plastic,
speakers, bicycle parts, keyboard, wire, feathers, turquoise, obsidian
approximately: 4'1" x 4'6" x 1'9"

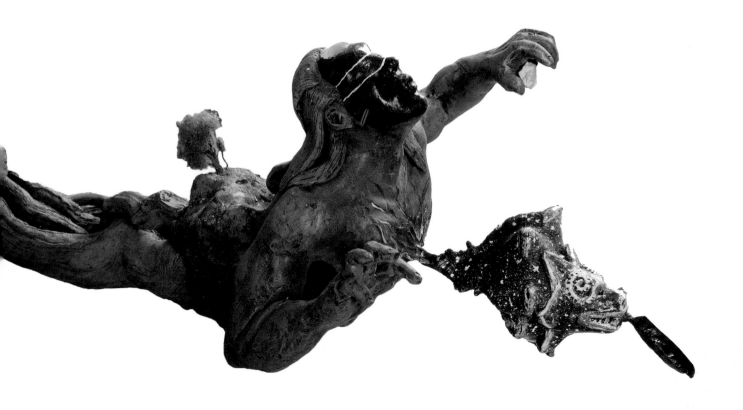

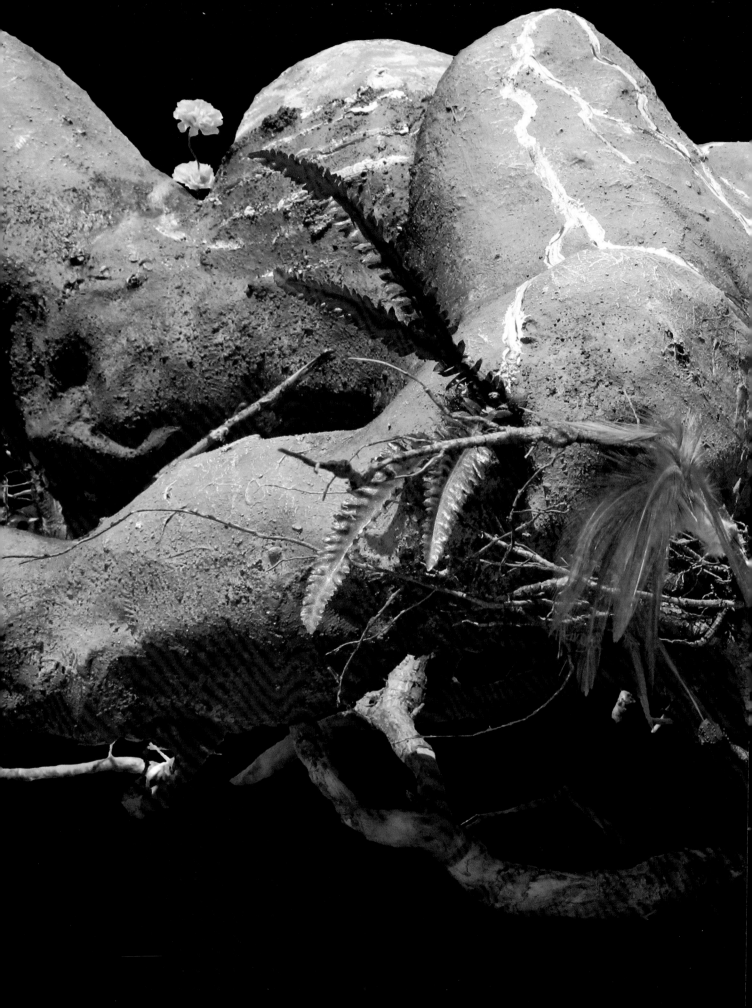

Tonantzin, 2012
Rebars, plastic garbage, tape, resin, roots, plastic plants, concrete, acrylic, feathers
approximately: 6'8" x 4'10" x 3'2"

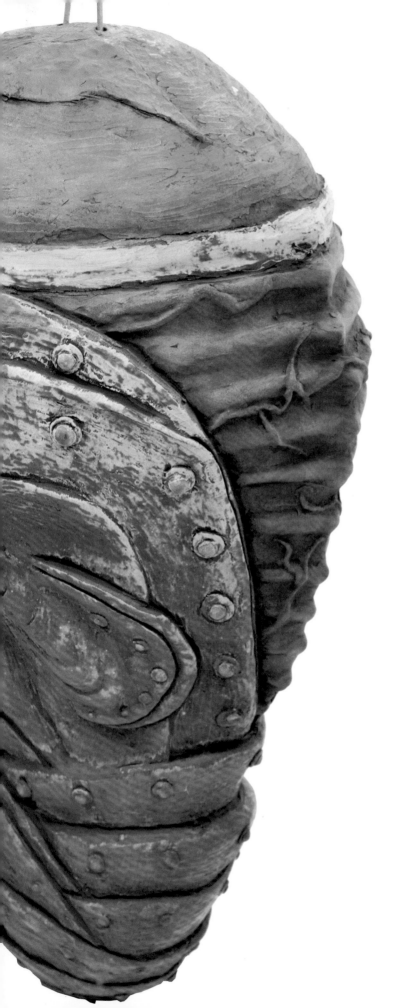

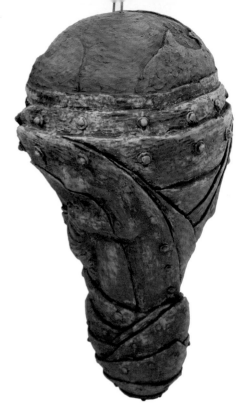

Metamorphosis, 2013
High-fire clay, oxides, high-fire glaze, wire
approximately: 2' x 1' x 1'2"

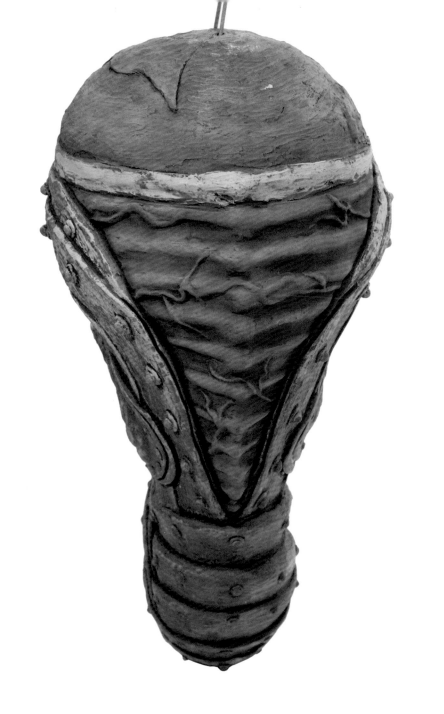

METAMORPHOSIS

Fue un sueño, tan solo un sueño (detail), 2013

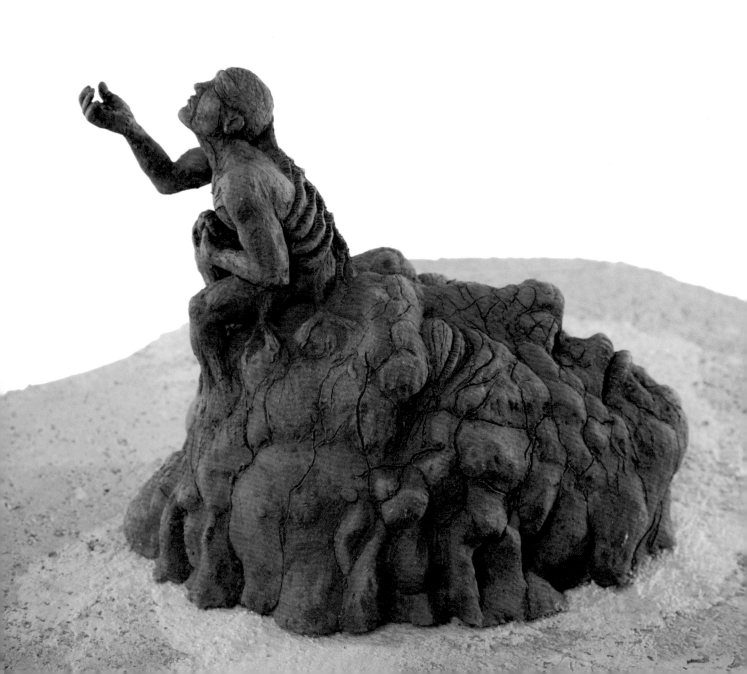

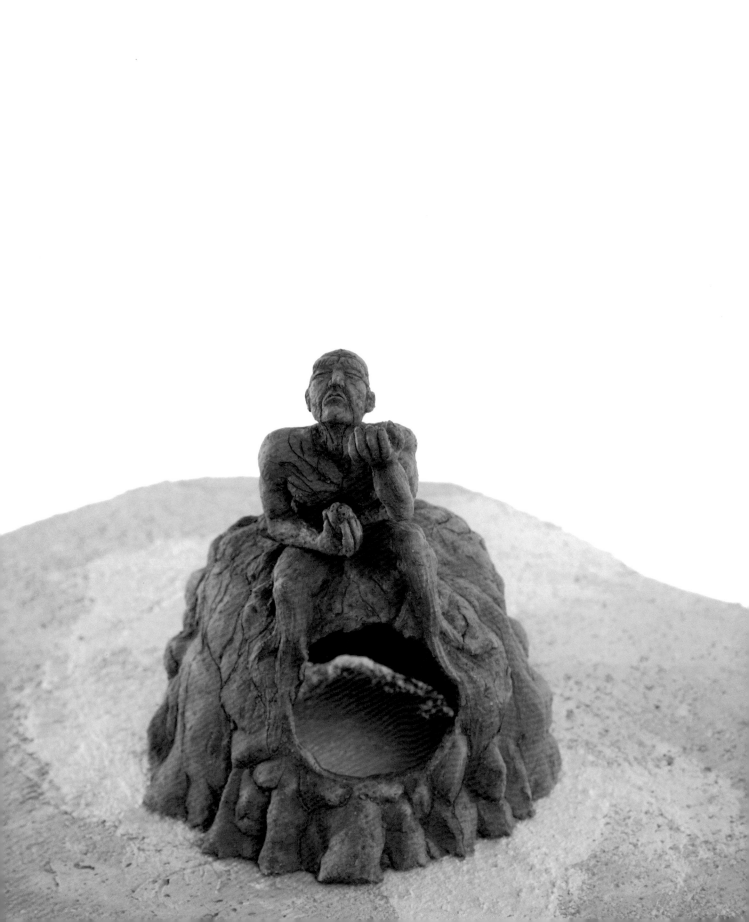

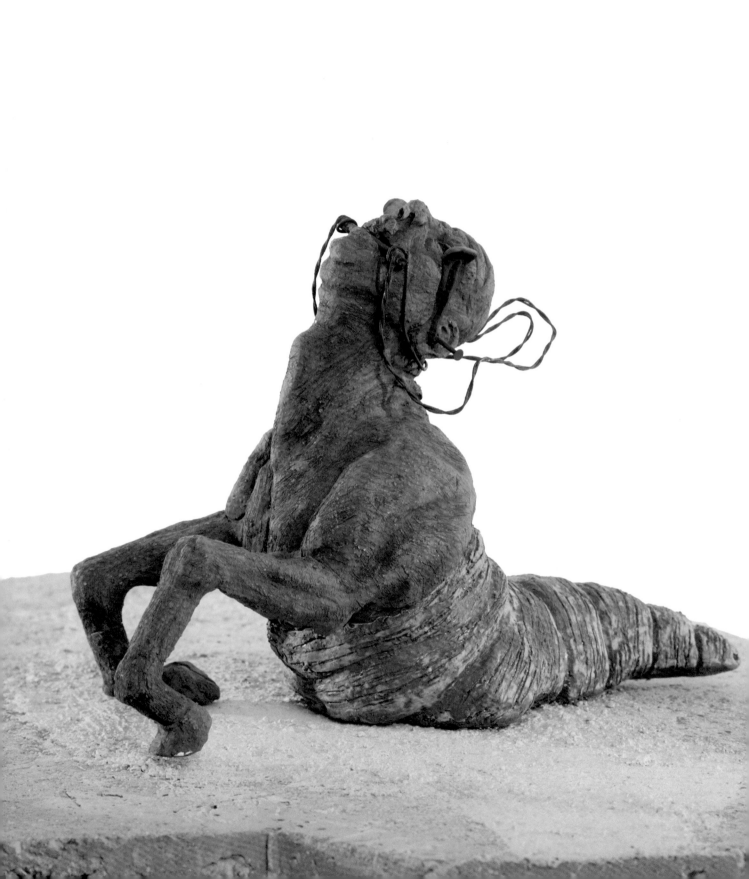

Fue un sueño, tan solo un sueño (detail), 2013

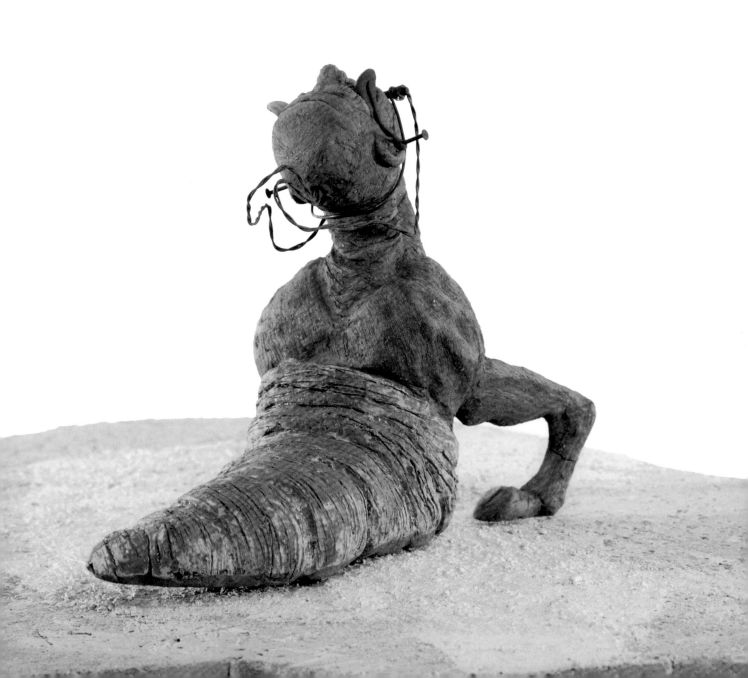

Fue un sueño, tan solo un sueño (detail), 2013

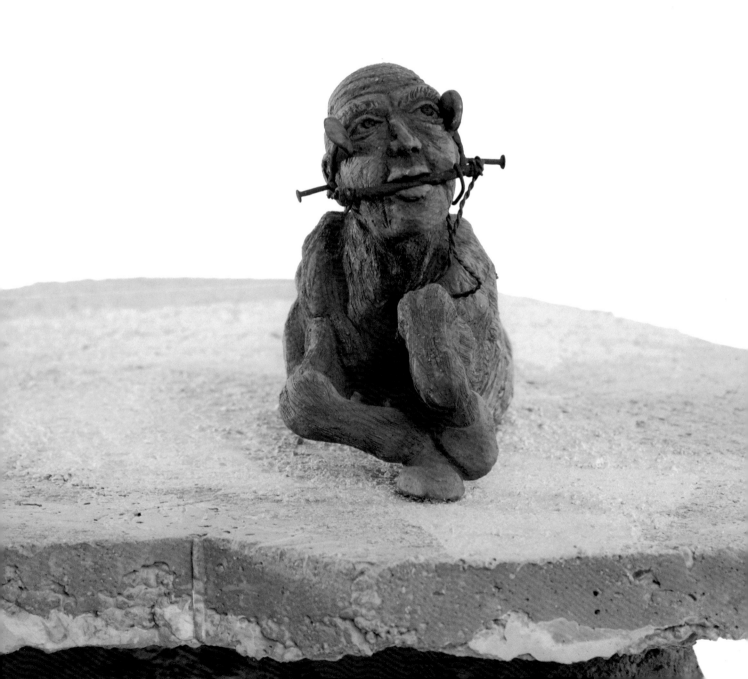

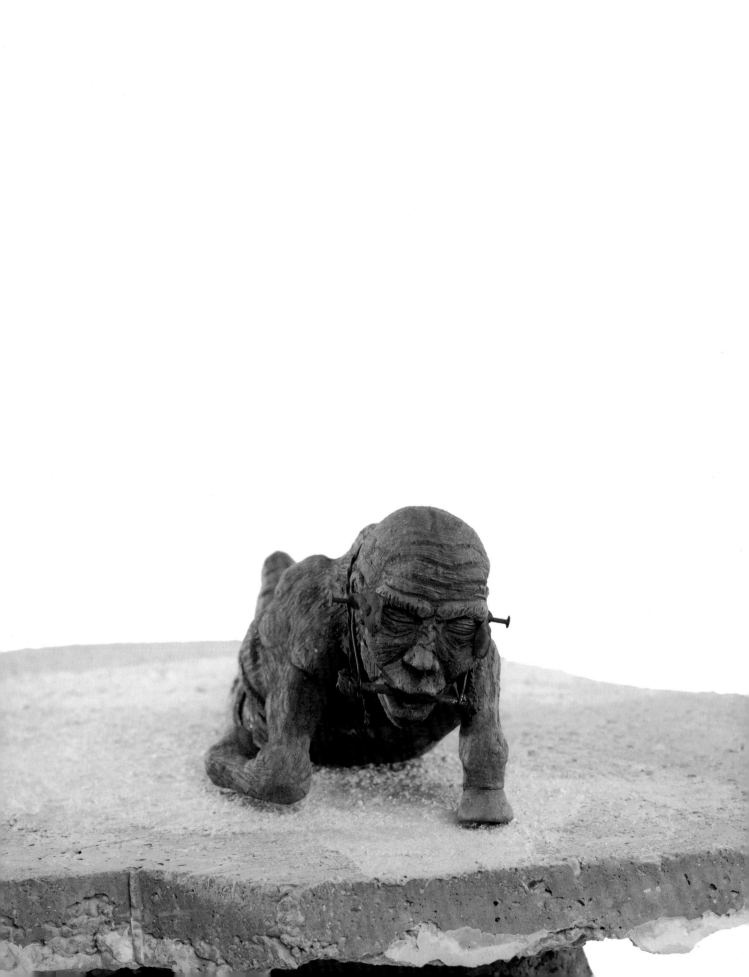

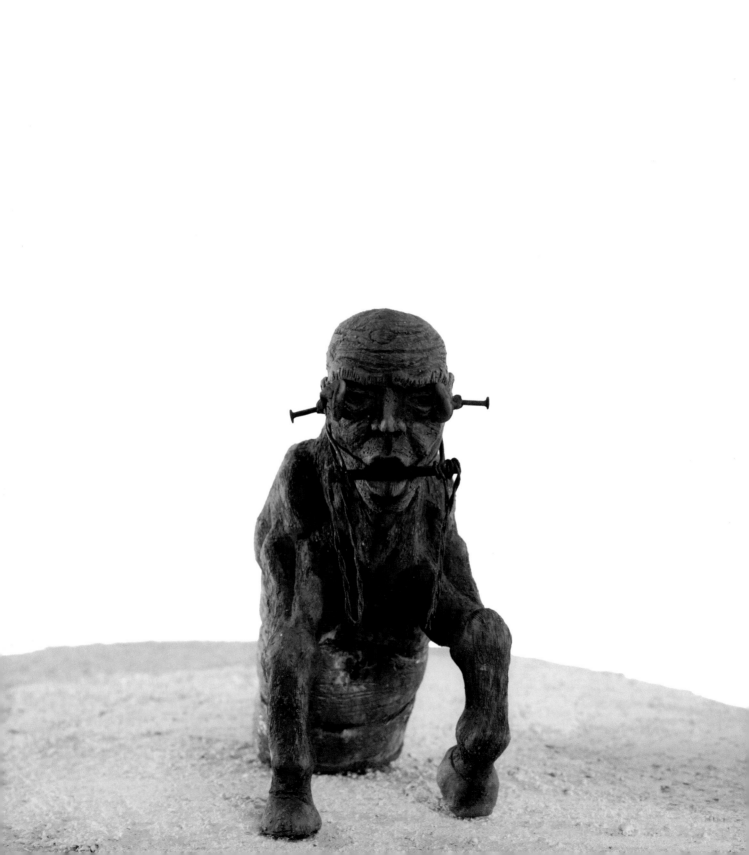

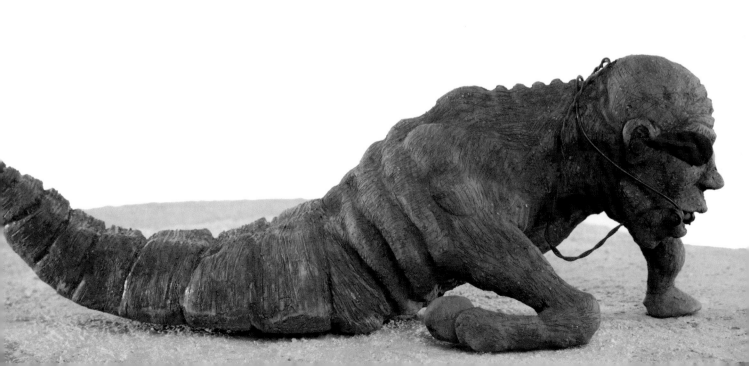

Fue un sueño, tan solo un sueño (detail), 2013

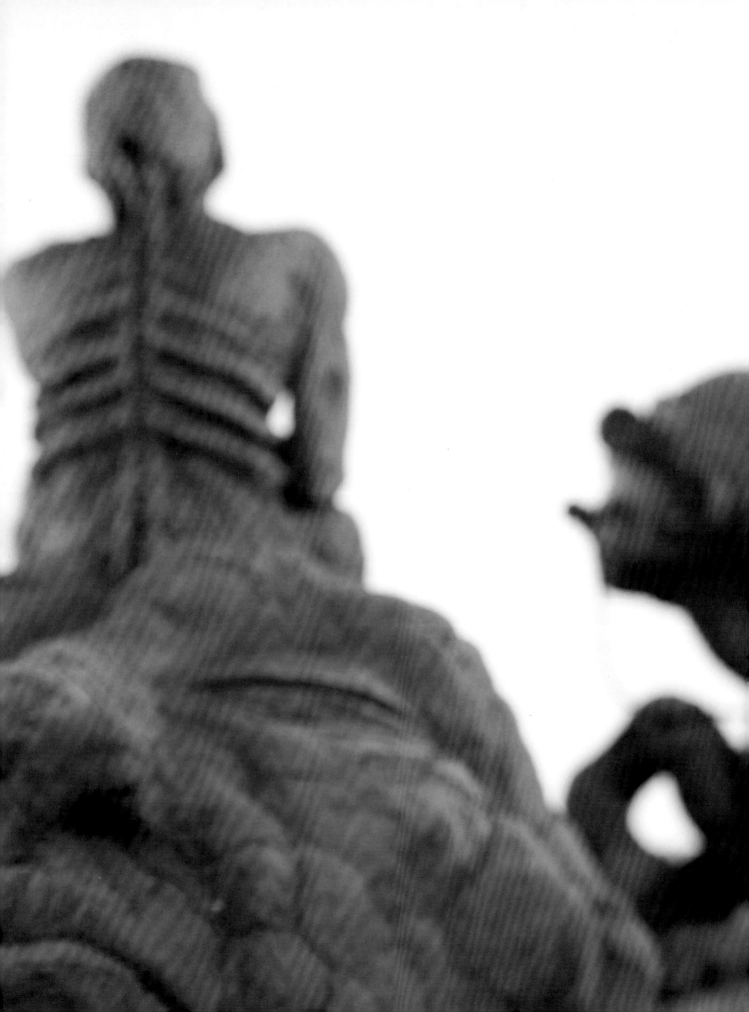

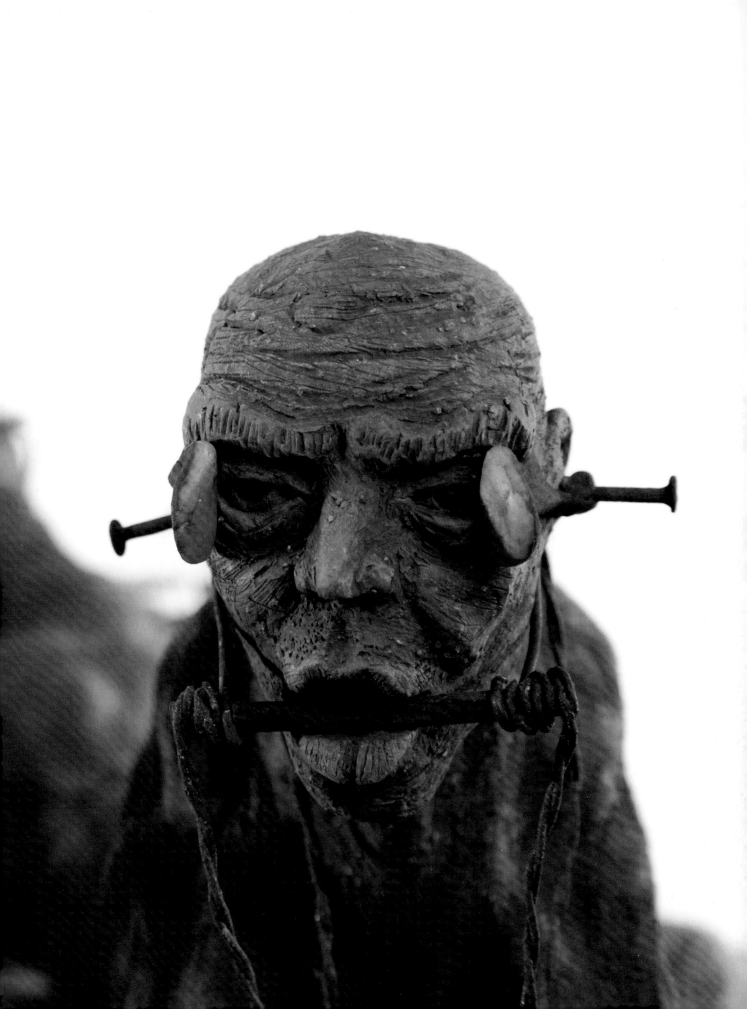

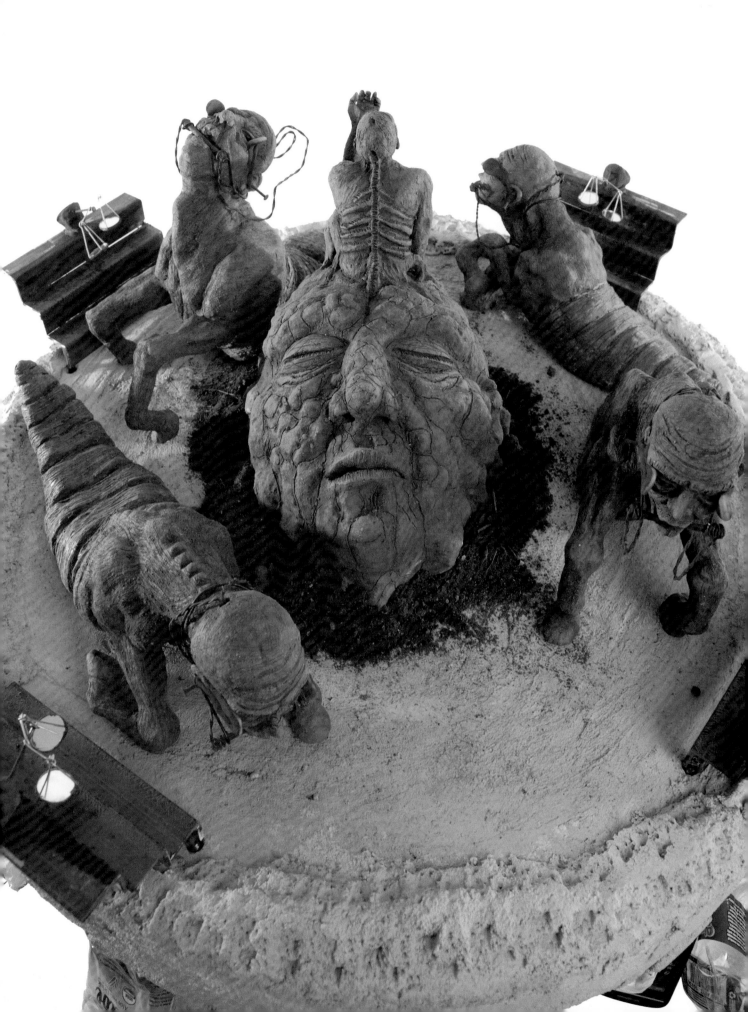

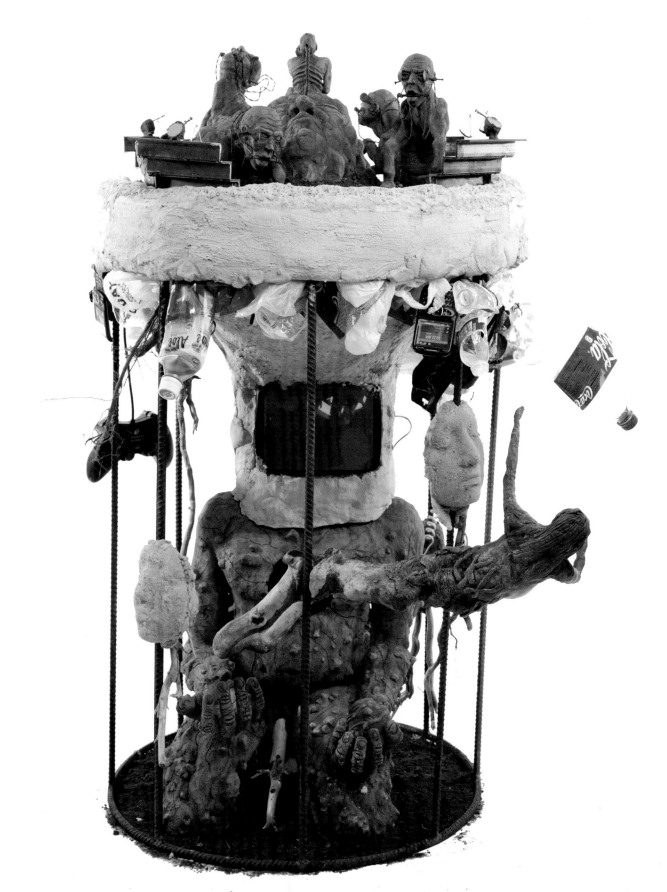

Fue un sueño, tan solo un sueño, 2013
High-fire clay, oxides, high-fire glaze, concrete, rebars, roots, wire, plastic garbage,
TV, mirrors, nails, epoxy, acrylic, steel, soil
approximately: 4'2" x 2'7" x 3'1"

Militar en cueros, 2013
High-fire clay, oxides, high-fire glaze, concrete, rebars, auto part, roots, wire, plastic garbage, mirrors, acrylic
approximately: 4'2" x 2' x 1'11"

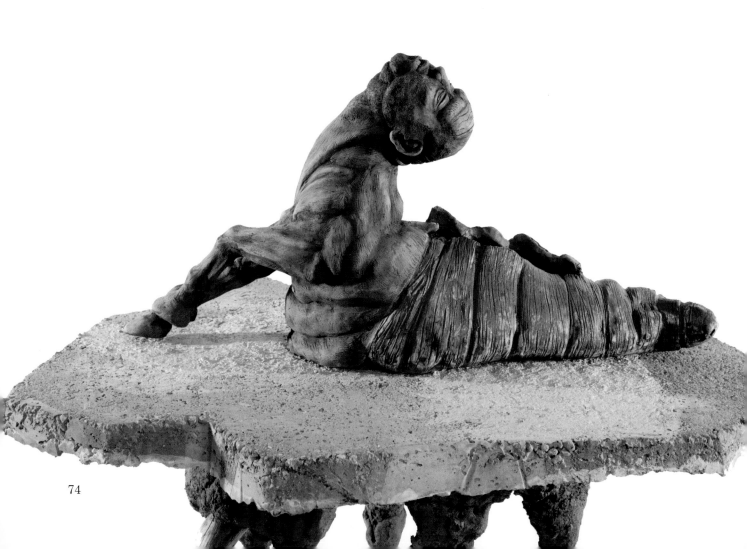

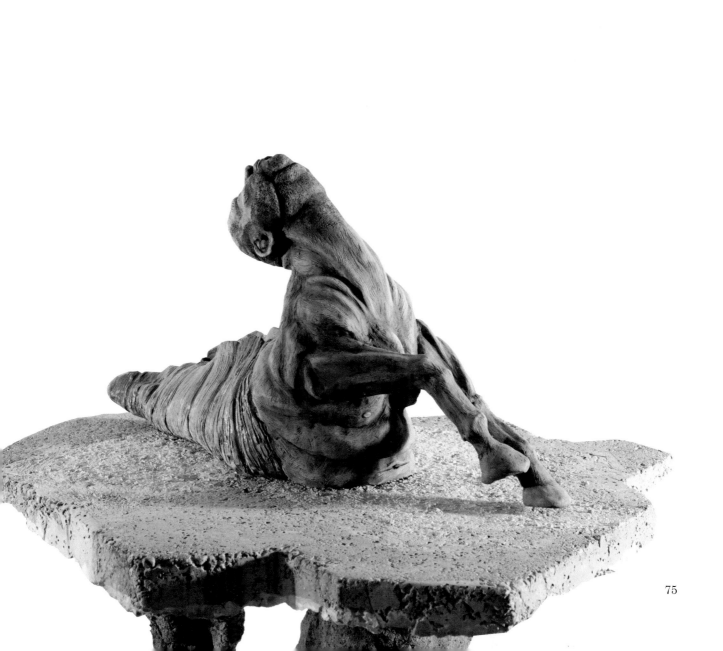

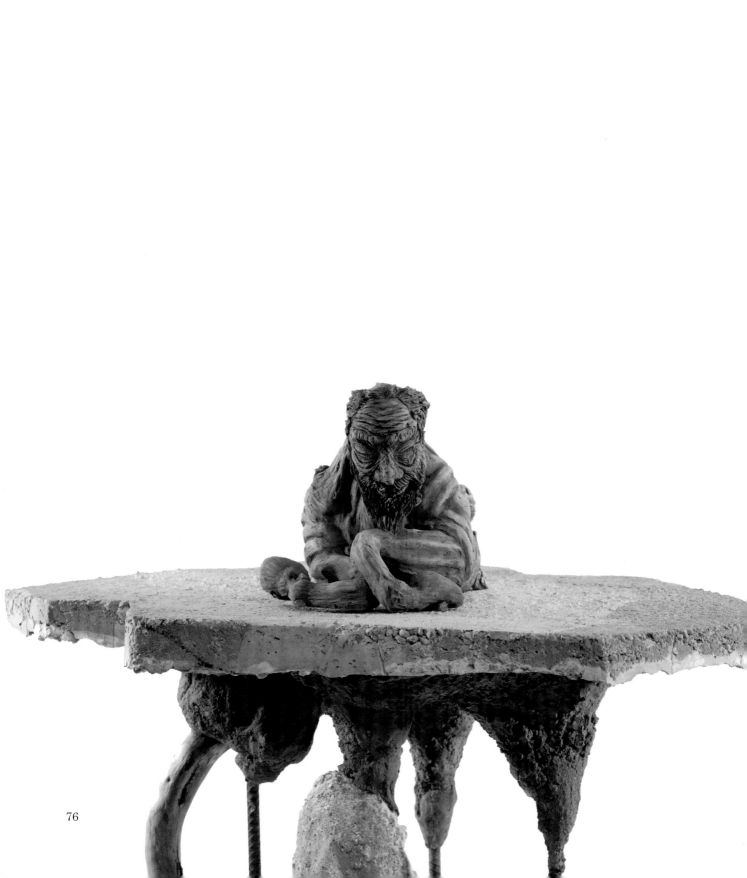

El Wino, 2013
High-fire clay, oxides, high-fire glaze, concrete, rebars, auto part, roots, wire, plastic garbage, mirrors, acrylic
approximately: 3'10" x 1'5" x 1'2"

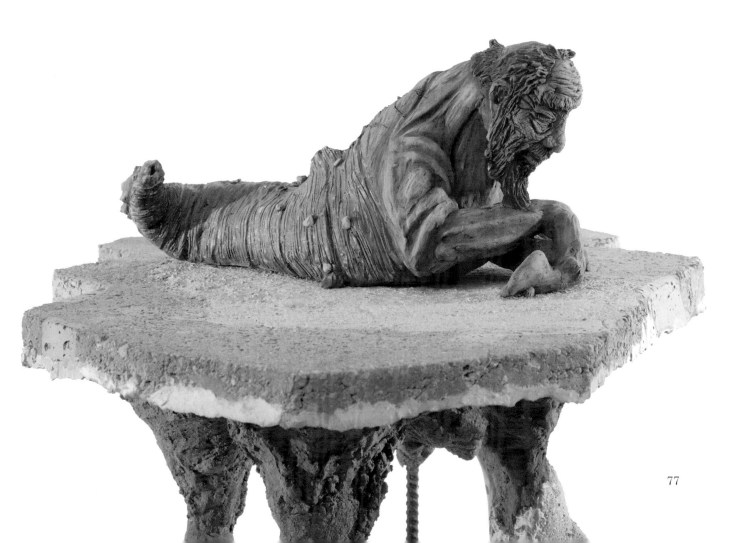

No More Pain, 2013
High-fire clay, oxides, high-fire glaze, concrete, rebars, auto part, roots, wire, plastic garbage, mirrors, acrylic
approximately: 4'2" x 1'9" x 1'3"

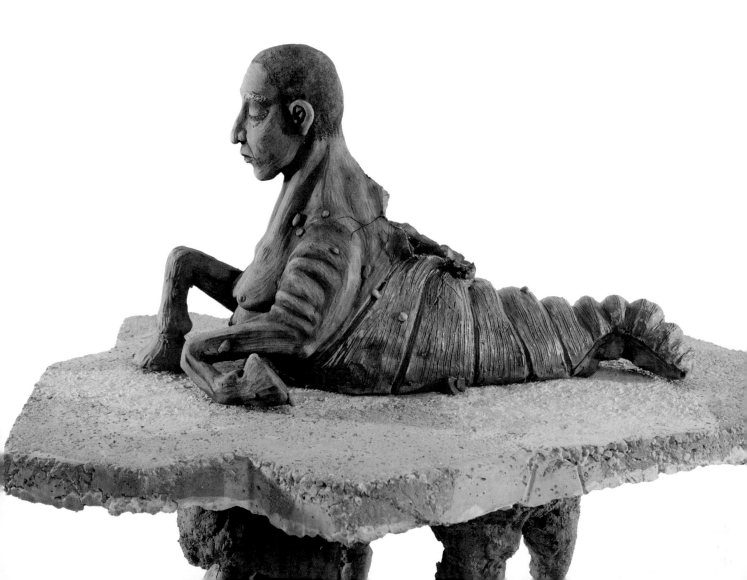

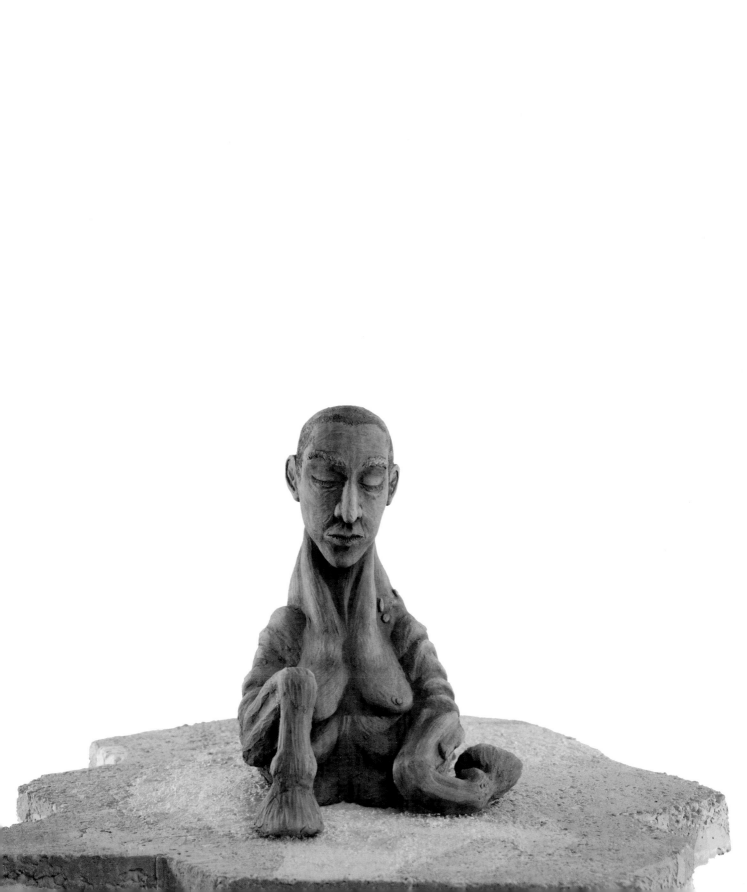

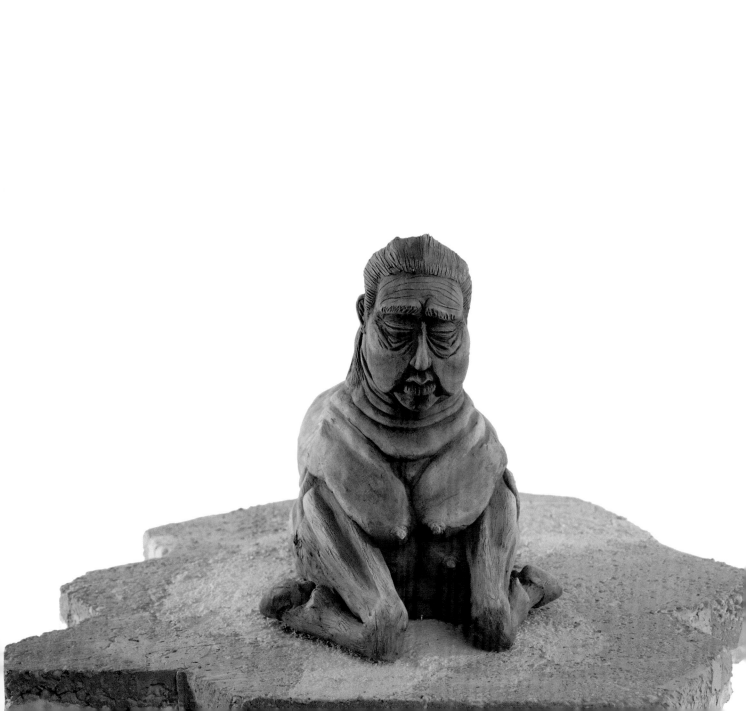

La Bolis siempre tan guapa, 2013
High-fire clay, oxides, high-fire glaze, concrete, rebars, auto part, roots, wire, plastic garbage, mirrors, acrylic
approximately: 4'1" x 1'9" x 1'3"

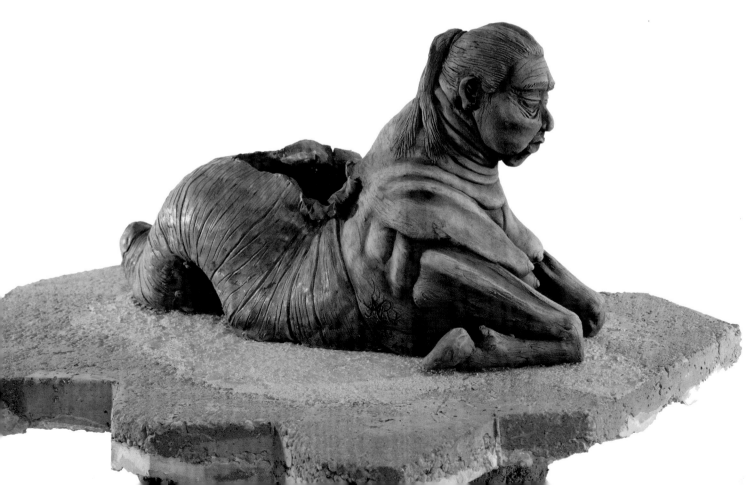

El hípster que se encontró, 2013
High-fire clay, oxides, high-fire glaze, concrete, rebars, auto part, roots, wire, plastic garbage, mirrors, acrylic
approximately: 3'11" x 1'10" x 1'3"

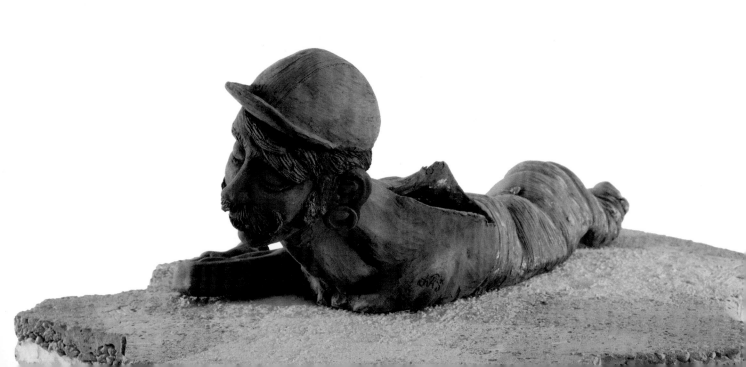

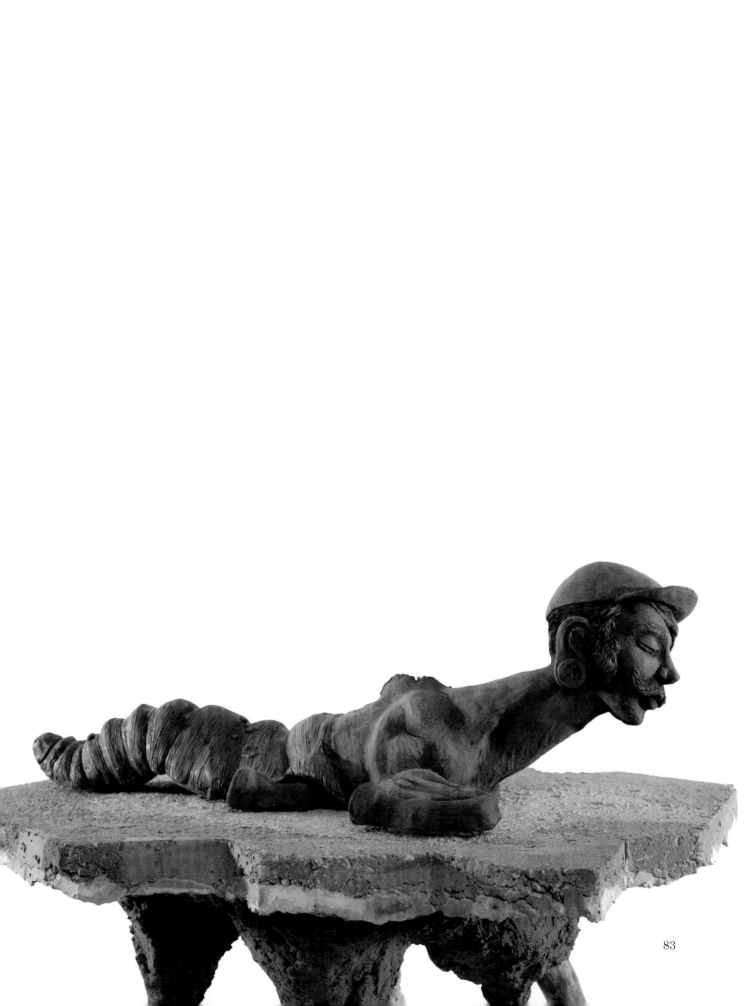

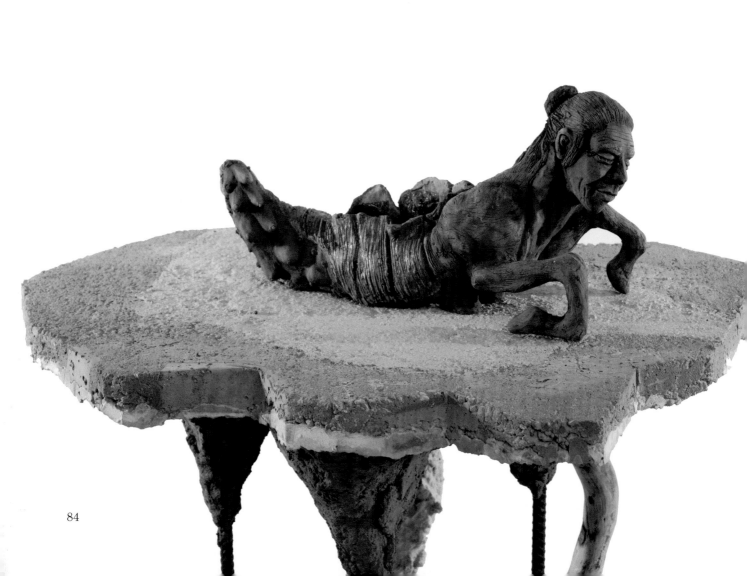

Lady Avon, 2013
High-fire clay, oxides, high-fire glaze, concrete, rebars, auto part, roots, wire, plastic garbage, mirrors, acrylic
approximately: 3'10" x 1'5" x 1'5"

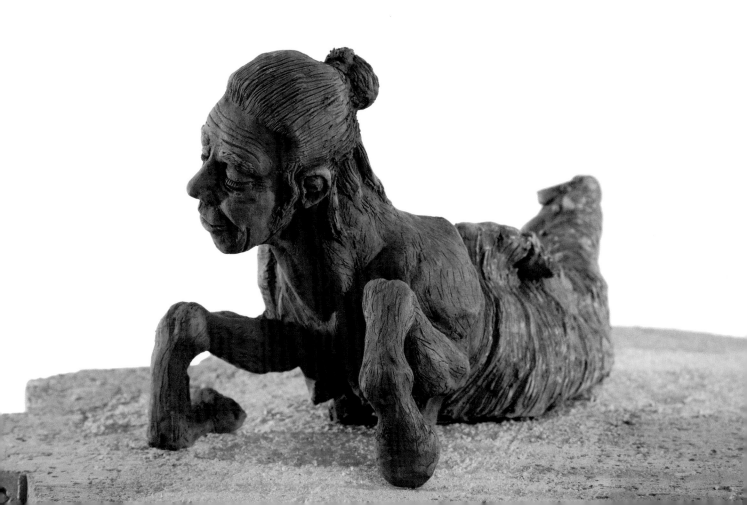

Finally Free, 2013
High-fire clay, oxides, high-fire glaze, concrete, rebars, auto part, roots, wire, plastic garbage, mirrors, acrylic
approximately: 4'3" x 1'6" x 1'2"

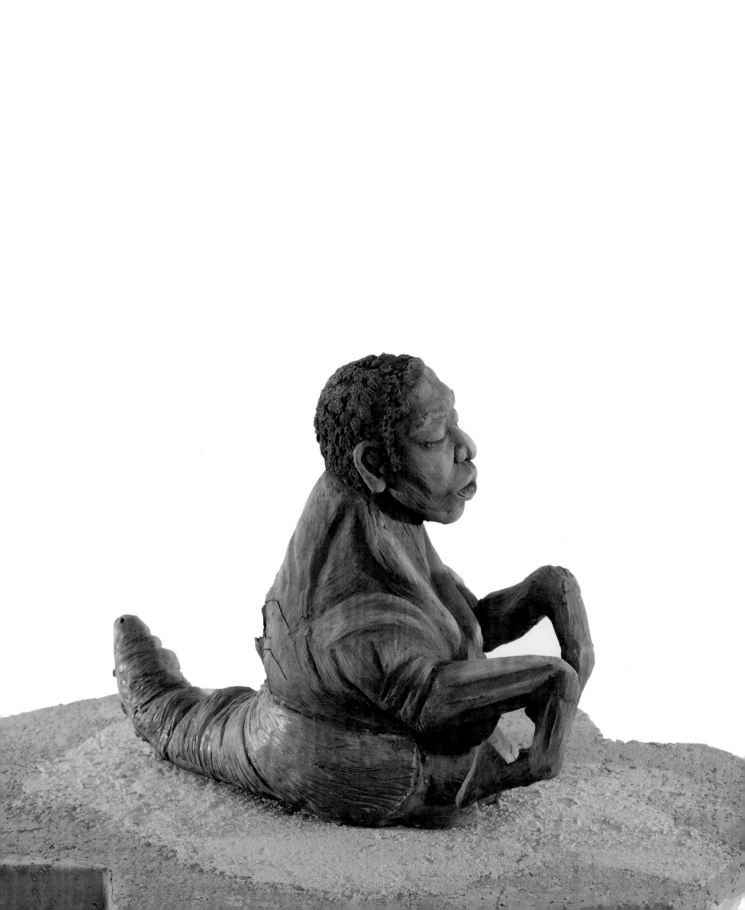

Encuentro con Cihuacóatl, 2013
High-fire clay, oxides, high-fire glaze, concrete, rebars, auto part, roots, wire, plastic garbage, mirrors, acrylic
approximately: 3'7" x 1'9" x 1'2"

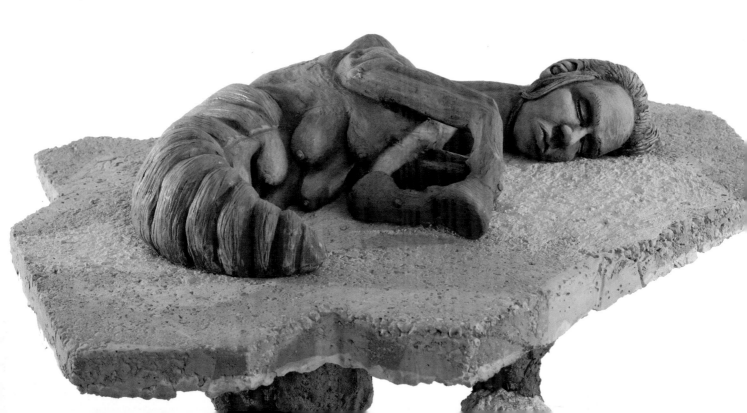

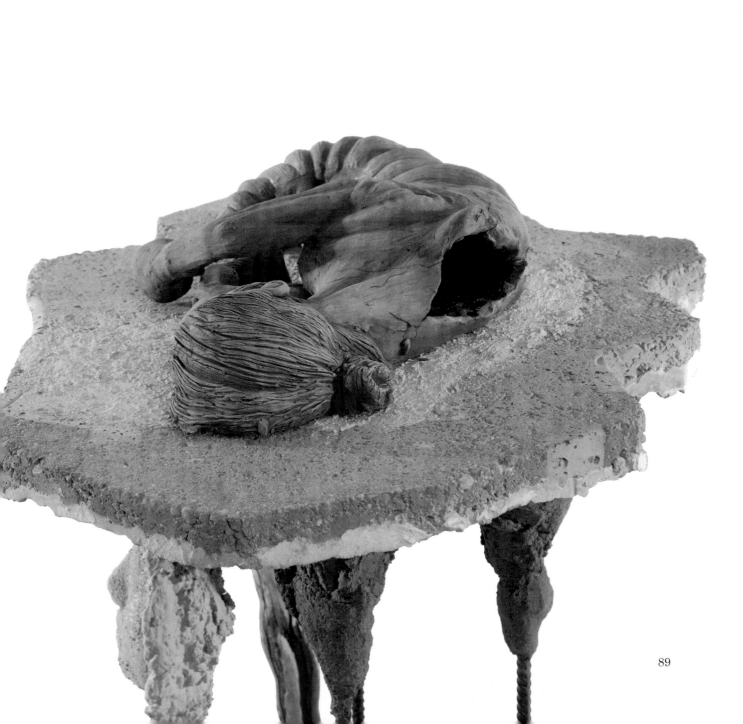

EL CEO de otros tiempos, 2013
High-fire clay, oxides, high-fire glaze, concrete, rebars, auto part, roots, wire, plastic garbage, mirrors, acrylic
approximately: 4'3" x 2'4" x 1'8"

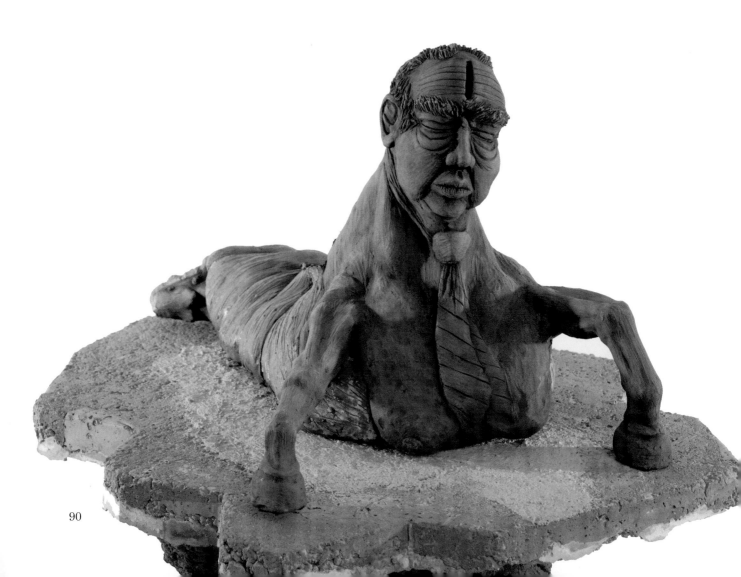

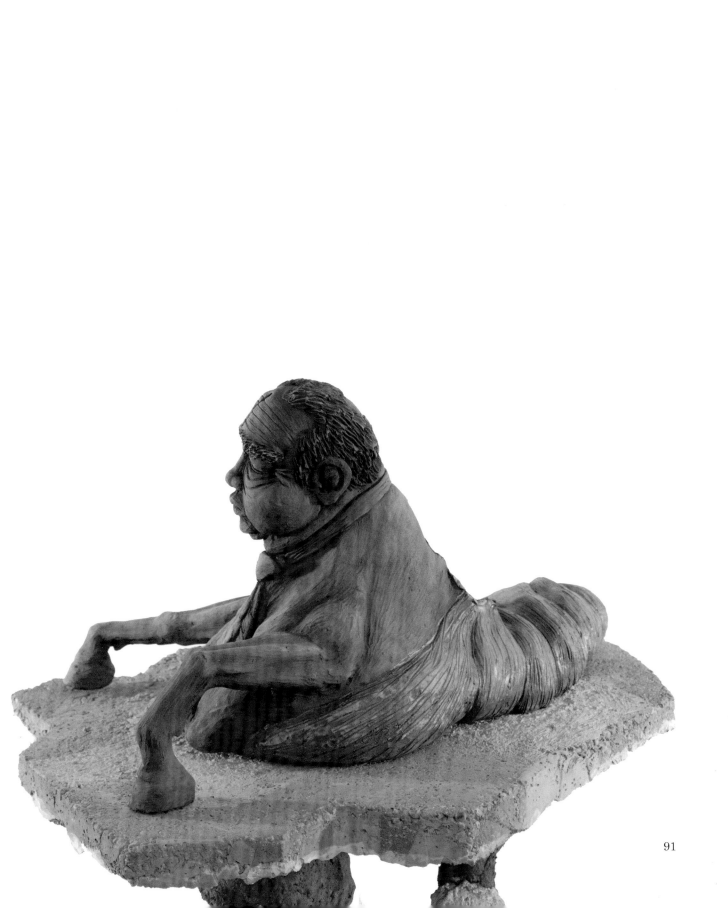

El árbol de la vida, 2013
High-fire clay, acrylic, feathers, mirrors, epoxy, concrete,
electronic boards, wood, roots
approximately: 5'5" x 5'10" x 1'2"

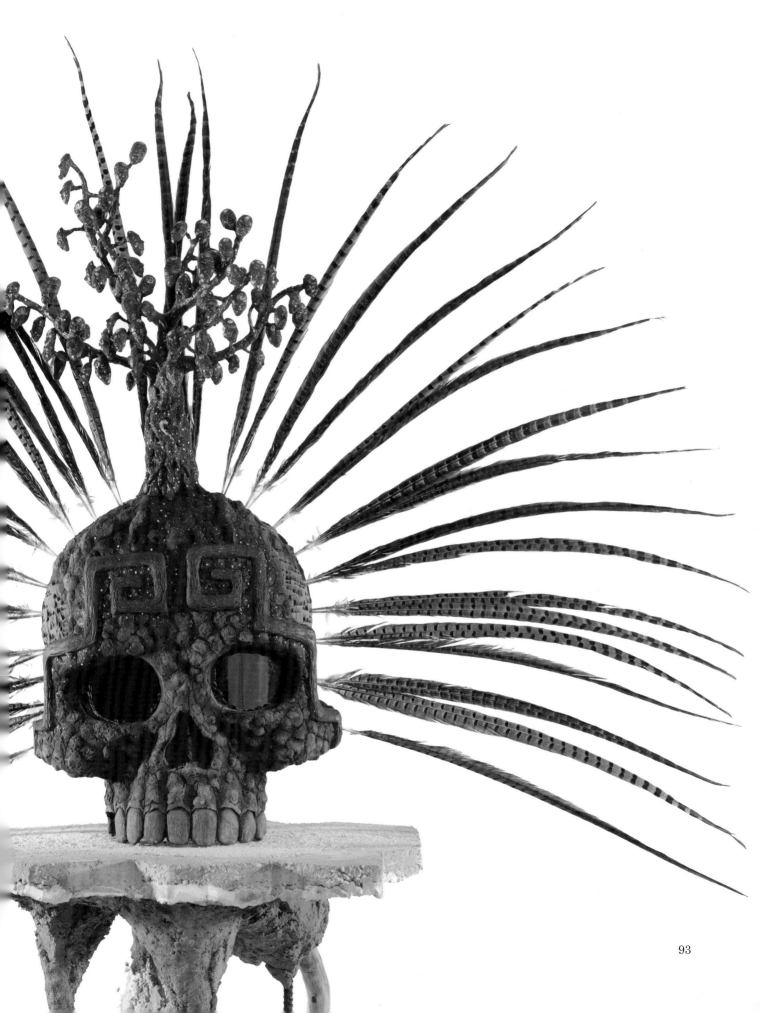

Alfonso Piloto Nieves Ruiz

EXHIBITIONS

Pulso: Art of the Americas (2013) Collective Show at Urban Institute for Contemporary Arts, Grand Rapids, MI

Transfiguration (2013) Solo Show at 33 Contemporary Gallery at the Zhou B. Art Center, Chicago, IL

50 Artisti per un Museo (2013) Museo MIT, Torino, Italy

Metamorphosis (2013) Noyes Cultural Center, Evanston, IL

Peace, War, and More War (2013) Out of Line Gallery, Chicago IL

Chicago's Twelve: 12 Artists Mobilizing the Earth (2012)

> Garfield Park Conservatory, Chicago, IL (August – December)

> Zhou B. Art Center, Chicago, IL. (April – June)

Return to My Roots (Para regresar a mis raíces no necesito estas pinches muletas) (2012)

> Solo Show at Calles y Sueños Gallery, Chicago IL

Facemask: Exploring the "Other" Behind Our Social Media Face (2012)

> 33 Contemporary Gallery at the Zhou B. Art Center, Chicago, IL

> Award for Excellence in 3D Art

Grand Rapids ArtPrize (2012) Gran Rapids, MI

Two person show with Nicole Marroquín: Cabeza de Barro (2011) National Museum of Mexican Art, Chicago, IL

> One piece became part of the permanent collection

CelebrArte: Celebrating the Latino Spirit, Imagination, and Creative Force in Chicago (2011)

> 33 Contemporary Gallery at the Zhou B. Art Center in collaboration with Latino Fashion Week

CGE Third Annual Green Arts Show (2011) Noyes Cultural Center, Evanston, IL

> People's Choice Award

7th Annual National Self Portrait Exhibition at 33 Contemporary Gallery at the Zhou B. Art Center (2011)

> Award for Excellence in 3D Art

North Park Art Walk (2010 – 2011) Group show, Chicago, IL

Red Bull Art of Can at River East Art Center (2007) Chicago, IL

> Awarded 2nd Place

Marcos Raya vs. Piloto (2007) Pilsen Open Studios at La Casa de la 18, Chicago, IL

Arte Popular (2007) Group show at The Smart Museum, University of Chicago, Chicago, IL

Two person show with Carlos Cortez (2001) Around the Coyote Gallery, Chicago, IL

PUBLIC ART

Cool Globes (2007) Co-created Creative Innovation Globe – Northerly Island, Chicago, IL

Metal 3-D Logo (2007) Co-created for Jim Beam Headquarters, Claremont, KY

Why Have You Forsaken Me? (2001) Mural in Lakeview Learning Center, Chicago, IL

TEACHING

Santa Fe Clay — Teaching Assistant with Rodrigo Lara Zendejas, Santa Fe, NM (2013)

Ten Thousand Ripples, Gad's Hill Community Center, Chicago, IL (2013)

ElevArte Community Studio — Teaching Artist, Chicago, IL (2011 – present)

Chicago Teachers' Center — Teaching Artist, Chicago, IL (2006 – 2011)

National Museum of Mexican Art — Yollocalli After-School Youth Program (2010 – 2012)

 Chicago Public Art Group — Mosaic Mural Project (grades 9-12)

 After School Matters — Pop Art semester (grades 9-12)

 Workshop for Chicago Public School Teachers

Glenbrook South High School, Glenview, IL (2008 – present)

 Teaching Art in Latin American History classes

Casa Aztlán, Pilsen neighborhood community center, Chicago, IL (2009)

 Youth in Action Program (grades K-5)

Mexican Folk Art workshops, Chicago, IL (2003 – present)

 Casa Guanajuato

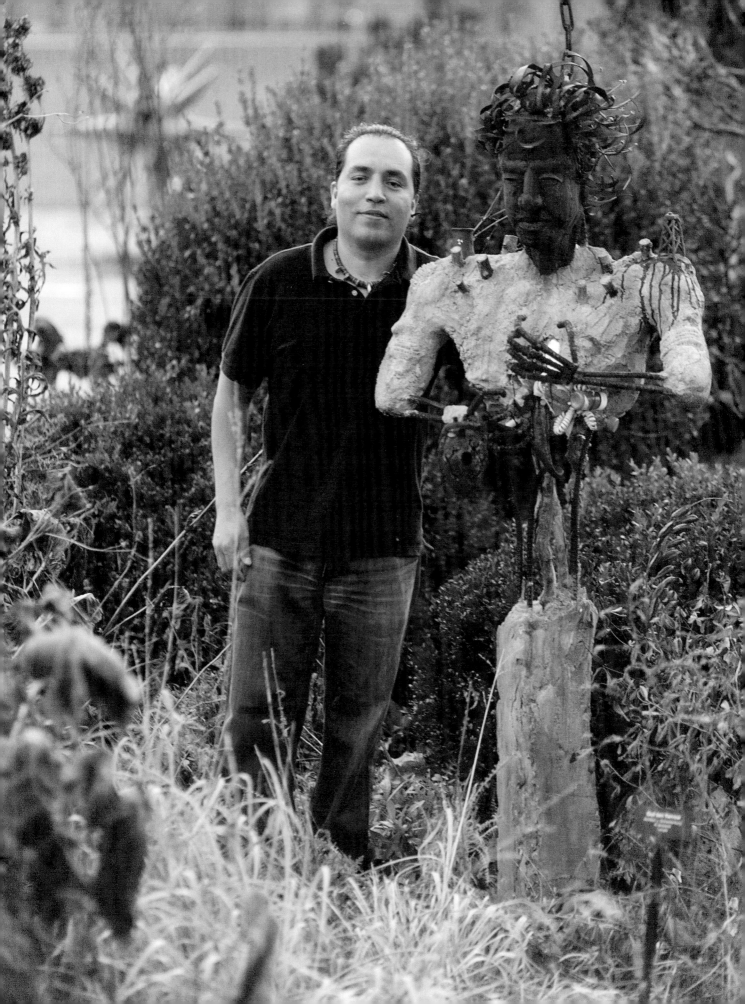

ACKNOWLEDGMENTS agradecimientos

PATRONS
Benjamín Fernández Galindo
Rodrigo Lara Zendejas
Linda Lutton
Eddie Mascorro
Marisol Mireles
Lizbeth Nieves Ruiz
FEDECMI/Casa Michoacán
TEKs Design
Prather Paint & Window Fashion

CUATACHOS
Iva Neal
Anne Berkeley
Erika Berumen
Michael DeVries
José Luis Gutiérrez
Amir Normandi
Dana Mayor & Mike Kanovitz
Melissa Mcneal
Kasia and Adrian Urbanowicz
Zdenek Lvovsky
Ewelina Wojciechowska
Dana,Lungelo and Zola Kuzwayo
José F. García
Felipe, Erika & Mar
Federación de Hidalguenses

BANDA
Santos y Mari Arce
Marta Ayala
Jeremy Bitterman
Luis Chávez

El Ché
Verónica de la Vega
Jesse Goodman
José Guzmán
Lara Kaage
Max and Laura Marshall
Diana Leviton Gondek
Gosia Marczewska & Henryk Krol
Aga Podczaszy
Laura R. and Ignacio Nuñez
Felipe Rodríguez
Julia Velázquez

AYUDA CON MIS MONITOS
Santos Arce
Antonio Bucio
Fernando Caldera
Felipe Camacho
Laura Crotte Occelli
Alma Domínguez
Stephanie Escobedo
Eddie Mermaid
César M. Pelayo
Josué 'Killer' Nieves Ruiz
Gerardo Quintero Rivera
Abiff Romeo 'Kabuto' D'Brickasaw Ramírez Ruiz
Gustavo 'El Flaco' Salinas

SUPPORTERS
Carlos Bueno
Mike Dillon
Christina Obregón
Calles y Sueños

ARROYO
PHOTOGRAPHY AND IMAGING
WWW.TIMARROYO.COM

Magda Marczewska
photography
www.marczewska.com

Un agradecimiento especial a todos los que se han cruzado por mi camino, haya sido grata o ingrata la experiencia, pues todos me han invitado a explorar los distintos caminos que me han llevado a donde estoy. Ah, y también al que me puso a chambiar y convirtió un folletito de cinco hojitas en un libro. Y por último, como no me alcnazó para el itacate en Chicago, lo tuve que mandar a imprimir a China: ahí ustedes disculpen. ¡Muchas gracias!

A la banda de la Sate, la colonia España, el Tepe, el fut americano, el rock 'n roll, Pilsen y muy especialmente a mi familia de México y Chicago, Emilita y Río.

~Piloto

FELLOW COLLEAGUES
Frank Díaz
José García
Barbara Goldsmith
Amir Nour
Sheila Oettinger
Pedro Pulido
Matthew Runfola
Dominic Sansone
Valerie Schiff

AYUDA DE SIEMPRE
Carlos Cortez
Héctor Duarte
José F. García
Anka Karaparowizz
Roberto López
Omar Magaña
Judy Petacque
Antonio Rangel
Marcos Rivera
Marco A. Tellez
Lun Tonsing
Roy Villalobos
Diablero Design
Casa Guanajuato

FUNDRAISING
Elia Badillo
Amara Betty Martin
Tonatiuh de la Cruz
Danka Durkiewicz
María Félix
Aga Furtak
Jaime Garza
Ramón Marino
Gosia Marczewska
Víctor M. Montañez
Candelaria Música
Josué I. Nieves Ruiz
Pill Project
Tomás Ramírez
Jesús Rojas
Gustavo Sánchez
Alfonso Seiva
Edgar Solorzano
Luis Tubens
Joaquín Velasco
Meztli
Las Palmas Restaurant

CONTRIBUTORS

BRENDA BAUTISTA studies philosophy at the National Autonomous University of Mexico (UNAM). She has participated in the following colloquiums: Symposium in Defense of Philosophy at School of Graduate Studies (FES), Acatlán, 2009; First, Second and Third Colloquium in Philosophical Thought in Mexico: 2009 – 2010 (FES), Acatlán. Participated in the International Mobilty Program UNAM-Universidad de Antioquía, Medellín, Colombia, 2011. She is a contributor to the online magazine *Pilsen Portal*.

SERGIO GÓMEZ, M.F.A. Northern Illinois University is a Chicago based visual artist. His paintings have been included in exhibitions in the United States, Italy, Austria, Stockholm, Mexico, Spain and Sweden. His work is included in private and public collections such as the Brauer Museum of Art and the National Museum of Mexican Art among others. Sergio Gómez is Director of Exhibitions at the Zhou B. Art Center, owner of 33 Contemporary Gallery, contributor for *ItaliaArte Magazine,* founder of *VisualArtToday.com,* Art/Design faculty at South Suburban College, Creative Consultant for Idea Seat Marketing and Advertising and co-founder of 3C Wear LLC. Additionally, Sergio has established international art collaborations in Turin, Vienna, Mexico, Chile and China.

KARI LYDERSEN is a Chicago-based reporter specializing in energy, the environment, labor, public health and immigration issues, and the myriad and complicated way such topics intersect. She currently works as a research associate for the Medill Watchdog Project at Northwestern University, and she also writes regularly about energy for Midwest Energy News and about labor issues for *In These Times* magazine along with writing for other publications including *Crain's Chicago Business* and *GlobalPost*. She previously wrote for *The Washington Post* as a staffer in the Midwest Bureau, where she covered breaking news and feature stories around the Midwest and contributed regularly to the Science Page. She also wrote for *The New York Times* Chicago edition as a reporter for *The Chicago News Cooperative;* and she has written for other publications including *People Magazine, The Christian Science Monitor* and *The Economist.*

FRANCISCO PIÑA is a writer and graphic designer. He has co-founded several past and present cultural and literary magazines in Chicago: *Fe de erratas, zorros y erizos, Tropel* and *Contratiempo.* He is the co-author of the book *Rudy Lozano: His Life, His People* (Workshop in Community Studies, 1991). Piña was also featured in *Se habla español: Voces latinas en USA* (Alfaguara, 2000) and *Voces en el viento: Nuevas ficciones desde Chicago* (Esperante, 1999). He functioned both as editor and publisher of *Marcos Raya: Fetishizing the Imaginary (2004), The Art of Gabriel Villa* (2007), *René Arceo: Between the Instinctive and the Rational* (2010). Currently, he is the editorial manager of the online magazine *Pilsen Portal.*

DIANA HINOJOSA is a writer and musician from Chicago. Although she pursued a degree in Political Science from the University of Arizona, her true life's passions are language and music. In 2011 she published *Pablo's Fandango,* a bilingual children's book based on Son Jarocho, a genre of Mexican folk music. She also translated the text and produced the accompanying music CD. Over the last decade, she has provided translation and interpretation services in Spanish, Italian, and French. She is currently writing for *The Resurrection Project* monthly newsletter, a non-profit organization based in Chicago and has a romance language reference book in the works, which she hopes to publish by 2015.

JORGE MONTIEL. Paterson, New Jersey. He lived in Puebla, Mexico were he participated in the poetry workshop offered by Casa del Escritor. Jorge lives in Chicago since 2007, where he studies philosophy and Spanish literature at Northeastern Illinois University. In 2012 he was awarded the second prize in Concenso's poetry contest in Chicago. Some of his works have appeared in *Contratiempo* magazine, the anthology *En la 18 a la 1: Escritores de Contratiempo en Chicago* (Voces Sueltas, 2010), and the anthology *Susurros para disipar las sombras* (DePaul University, 2011).

PHOTOGRAPH CREDITS

TIM ARROYO
7, 11, 12, 14, 15, 16, 19, 20, 22, 36, 37, 38,
39, 40, 41, 44, 45, 46, 47, 48, 49, 50, 51, 52,
53, 56, 57, 60, 61, 62, 63, 64, 65, 66, 67, 68,
69, 70, 71, 72, 73, 74, 75, 76, 77, 78, 79, 80,
81, 82, 83, 84, 85, 86, 87, 88, 89, 90, 91, 92,
93, cover and back cover detail

THOMAS COSTANZA
34

EMILY EKSTRAND
35, 58, 59

AGNIESKA FURTAK
54, 97

SERGIO GÓMEZ
94, back cover: 33 Contemporary Gallery

MAGDA MARCZEWSKA
4, 8, 23, 24, 25, 26, 27, 28, 29, 30, 31, 32, 33

ALFONSO PILOTO NIEVES RUIZ
42, 43, 55

PILOTO